On the cover: The New Rochelle Post Office is elaborately adorned in red, white, and blue bunting for the 225th anniversary celebration of the founding of New Rochelle. Postal workers pose in front of the building during the June 1913 event. (Dominic Bruzzese Photograph Collection, New Rochelle Public Library.)

IMAGES
of America

NEW ROCHELLE

Barbara Davis

Copyright © 2009 by Barbara Davis
ISBN 978-0-7385-6509-5

Published by Arcadia Publishing
Charleston, South Carolina

Printed in the United States of America

Library of Congress Control Number: 2008942672

For all general information contact Arcadia Publishing at:
Telephone 843-853-2070
Fax 843-853-0044
E-mail sales@arcadiapublishing.com
For customer service and orders:
Toll-Free 1-888-313-2665

Visit us on the Internet at www.arcadiapublishing.com

*In memory of my grandparents Floy and Walter Burge
and Barbara and Kenneth N. Davis*

Contents

Acknowledgments		6
Introduction		7
1.	An Early American Settlement Begins Its Transformation	9
2.	New Rochelle's Sound Resorts	31
3.	Summer Homes in the Country, Philanthropy, and New Citizens	45
4.	Residential Parks Just 45 Minutes from Broadway	61
5.	Hometown America Becomes a 20th-Century City	77
6.	Fort Slocum and New Rochelle's World War I Years	101
7.	Boom Time through the 1920s	111
Bibliography		126
About the New Rochelle Public Library		127

ACKNOWLEDGMENTS

With the preservation and perpetuity of New Rochelle's significant history in mind, generous individuals have donated photographs, manuscripts, documents, maps, and books that now comprise the New Rochelle Public Library's exceptional local history collection. Dominic Bruzzese contributed most of the collection's images, including photographs, glass negatives, and postcards. This book would not have been possible without his lifelong relentless pursuit and his love for the town and its people. Karen S. Allen shares the same passion, and her donations over the past seven years have added invaluable depth and character to the collection.

The library's collection is properly maintained and accessible to the public due to the backing of the New Rochelle Public Library Board of Trustees and library director Tom Geoffino; financial assistance from the Friends of New Rochelle Public Library, the New Rochelle Public Library Foundation, and grants; and the hands-on professional care of trained librarians Beth Mills and Larry Sheldon and many other librarians and staff members.

The preservation and continuation of New Rochelle's great history relies on the support of New Rochelle's mayor, the city council, and the city manager. Mayor Noam Bramson and the current council and city administration deserve appreciation and credit for their efforts to make New Rochelle's past a key part of its future.

On a personal note, I have had the great pleasure to hear and record the stories of many longtime New Rochelleans. I am forever grateful for the insight and memories they provided. Along with imparting important historical information, the late Thomas Hoctor (city historian) and Patrick Barrett (superintendent of the New Rochelle Municipal Marina) also shared wonderful stories, great wit, and invaluable friendship. My sincere appreciation goes to kindred spirits Thea Eichler, Theresa Kump Leghorn, Rick Moody, June Schetterer, Billie Tucker, and the members of the New Rochelle and Huguenot Historical Society for all they do to keep New Rochelle's history alive and well. Singlea Hall, Mary Miceli, and Amy Tietz helped finalize the book. And my heartfelt thanks also go to my husband and daughter, Steve and Morgan Pappas, for their patience and support.

Unless otherwise noted, all images in this book are from the New Rochelle Public Library's local history collection, Dominic Bruzzese Photograph Collection, and Karen S. Allen Collection.

The New Rochelle Public Library's local history collection will be the beneficiary of my royalties from the sale of this book.

Every effort has been made to ensure the historical accuracy of the materials presented in *New Rochelle*. I welcome any comments regarding the book and its contents

Introduction

New Rochelle, a quiet agricultural town for its first 200 years, burgeoned into one of America's first and most fashionable residential communities in just a few decades. From the dawn of the 20th century through the Depression years of the 1930s, its farms were transformed into neighborhoods, the small hamlet took on the appearance of a glamorous retail center, and a Long Island Sound shore town became a diverse suburban city.

This period of astounding change is well documented in archival photographs and postcards. And thanks to New Rochelle collectors Dominic Bruzzese, Karen S. Allen, and other donors, the New Rochelle Public Library local history collection contains a treasure trove of these valuable images. Poignant cameos of the past, the archival pictures provide an enlightening perspective of New Rochelle's long and unique history—a three-century-long heritage that traces the patterns and trends of America, frequently with a twist.

In the early years of New York when only a few small hamlets dotted the forests and fields of what is now Westchester County, a small group of French Protestant refugees called Huguenots made their way to a stretch of land that began at the banks of Long Island Sound. Having fled their homeland to realize a life in which they could practice their Protestant religion freely, the dozen or so families, with Jacob Leisler acting as the go-between, purchased 6,000 acres from John Pell, signing the deed in 1689. They named it after the last Huguenot stronghold in France, the Port of La Rochelle.

These early settlers chose their new home wisely. The land was fertile and farmable. Its Long Island Sound location provided for abundant fishing, gainful tidal mills, and lucrative water-related trade and industry. The new community was connected to northern settlements and to New York by the Boston Post Road—the leading thoroughfare of the colonies, which traced the ancient pathways of the Siwanoy Indians along the sound shoreline. It was also only 18 miles to reach the French Church in Manhattan and about 24 miles to the mercantile hub of New York.

Despite their varied backgrounds, the merchants, landowners, tradesmen, and farmers that made up the first 40 or so families shared a desire to worship freely. They had the joint disadvantage of having little money or material goods. All had been left behind in France during their flights to safety.

The Huguenots were not alone in the establishment of this new community. Many brought slaves with them as they traveled through the West Indies before coming to New York. Records from 1698 give a count of 231 inhabitants. Of those, 43 were black, presumably slaves. In a letter from December 1727, Rev. Pierre Stouppe gave an account of his new flock and its environs, writing that there were about 400 persons in town, including two Quaker families, three Dutch, four Lutherans, and 78 slaves. Even earlier, around 1700, Michael Jechiel de Haas (Hays) is believed to have been the first Jewish settler in America. Of Sephardic descent, he sailed from

Holland to New York with his wife and children and began a farm in New Rochelle. A sixth son was born in 1732 (by a second wife, it is believed), becoming the first Jewish child born in Westchester.

Customs and manners from the Huguenots' homeland were retained well into the 18th century. Town meeting continued to be conducted in French until 1738. Records of those meetings are largely concerned with the height of fences, building roads, keeping livestock in check, and tending to the poor.

Thousands of British soldiers, along with colorfully uniformed Waldecker and Hessian troops, inundated the farms of New Rochelle during the critical weeks of the Revolutionary War in October 1776. En route to the battle of White Plains, on top of the ridge opposite North Avenue, Gen. William Howe commanded his British troops from the home of Quaker James Pugsley, whose land encompassed what is now Beechmont. In the lawless days immediately after the war, marauders attempted to hang Pugsley's daughter, Hannah. Local legend relates that a slave saved her. As the town records of August 15, 1799, document, Hannah Pugsley freed her slave, also named Hannah Pugsley.

The war took a heavy toll on New Rochelle and the other towns that dotted Westchester County. Families often chose conflicting sides; those who remained neutral were torn apart by the casualties of battle or the loss of homes and farms to raiders. Rebuilding was begun in earnest. The town records once again focused on matters dealing with day-to-day governance of a few hundred families. Crops were grown and milled for local use and to be shipped to New York or more distant destinations.

With the advent of the steamboat and then passenger rail service, New Rochelle's bucolic landscape was forever changed. Crowds of vacationers seeking a wholesome alternative to the dirt, crime, and overcrowding of New York City headed to the countryside for waterfront pleasures offered by hotels and resorts along New Rochelle's Long Island Sound shores. Wealthy vacationers built summer estates; middle-class families purchased homes in developing residential parks. The train also brought new immigrants to town—the New Rochelle station was the first stop on the New Haven line and a quick trip from the ferry dock off Ellis Island. The depot became the catalyst for shops, newspaper offices, banks, tearooms, and other enterprises that evolved into a permanent and thriving downtown.

In 1857, the Village of New Rochelle (950 acres) was established within the town of New Rochelle (the entire 6,100 acres). With its own president and board of trustees, the village eventually included most of the southern part of the community, from the stone wall that runs alongside the driveway into the current city hall to the sound. On April 24, 1889, the entire town, including the village, was incorporated as the City of New Rochelle. At the time, there were about 14,000 residents. By 1930, New Rochelle's population had exceeded 54,000.

The chapters that follow illustrate New Rochelle's most formative years, a remarkably vibrant period with unprecedented growth and development. The images present just a sampling of a much larger and more complex picture. Threads are missing simply because the images do not exist or have not yet found a home in the local history collection of the New Rochelle Public Library. It is hoped that the future will uncover many more reminders of New Rochelle's fascinating history and additional chapters of its boundless story.

One
AN EARLY AMERICAN SETTLEMENT BEGINS ITS TRANSFORMATION

The once-quiet farming community of New Rochelle was slowly taking on a new appearance by the 1860s. The tidal mills had all long closed, and several major farms had been sold for residential construction. The descendants of the Huguenot settlers had abandoned the dress, customs, and language of their French ancestors. The census of 1860 gives a telling tally: Of the nearly 4,000 people living in the town of New Rochelle, 30 percent were foreign born, including 800 residents from Ireland and 200 from Germany. Only six individuals had been born in France.

The most visible changes were happening near the train depot, where a business hamlet was rapidly growing to provide goods and services for the ever-increasing numbers of daily train riders. Early Huguenot names could still be seen on numerous signs of shops, trade services, and election ballots for town positions. Horses still pulled wagons and surreys and equipment for farming, ice cutting, and fighting fires. One public school provided instruction for the entire population of children except for a few scattered single-room schoolhouses in Upper New Rochelle. One was located in Cooper's Corners, which was the community's northern outpost, servicing the scattered farms and sparse population that extended to the Scarsdale and Mamaroneck borders. When the Civil War tore America apart, only 26 New Rochelle men fought in its battles. Those who served did so with valor. One made the supreme sacrifice. To keep their boys, husbands, and fathers home, the community raised a whopping $95,000 to pay for substitutes to serve in their places, as was the option of the country's first draft.

But the Civil War struck home unlike nearly any other northern town. Thousands of wounded Union and imprisoned Confederate soldiers were treated just off the southern shore of New Rochelle at DeCamp Hospital on Davids' Island.

The Huguenot heritage was still very much alive during the three decades following the Civil War, as seen in the images that follow in chapter 1. These rare glimpses of the past also show a community positioned for the 20th century and its turbulent, exhilarating times.

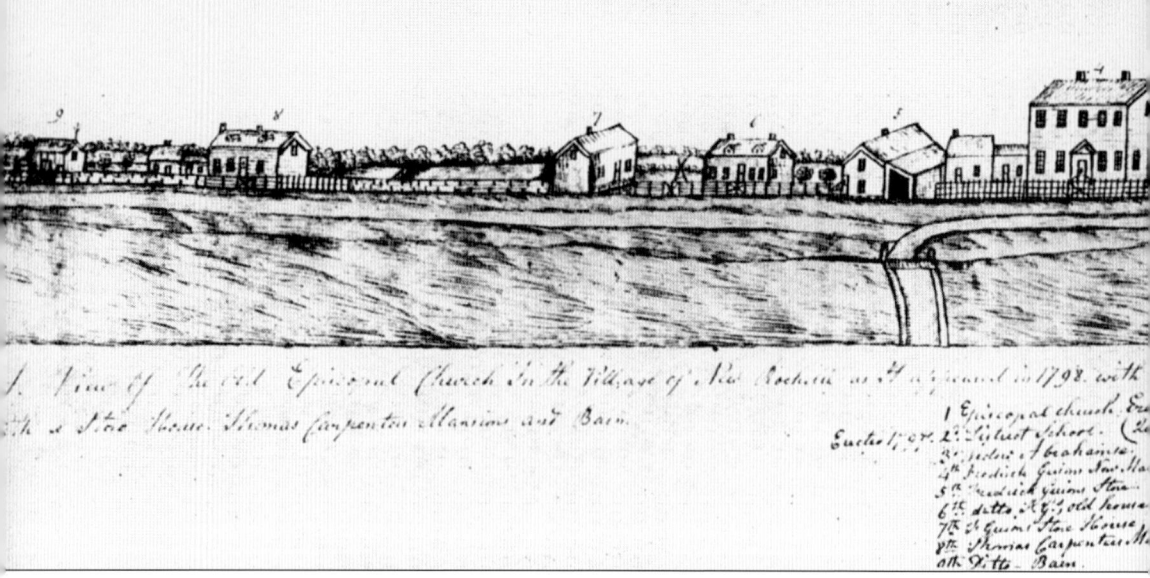

An illustration of the Boston Post Road (now Huguenot Street) in 1798 provides a rare and unusual view of New Rochelle's early town. In a letter from December 11, 1727, Rev. Pierre Stouppe described New Rochelle: "The present number of inhabitants amounts to very near four hundred persons. There is a dozen of houses near the church, standing pretty close to one another, which makes the place a sort of town; the remainder of the houses and settlements are dispersed up and down, as far as the 6,000 acres of land could bear." On this western view of the map, Centre Avenue leads down the hillside.

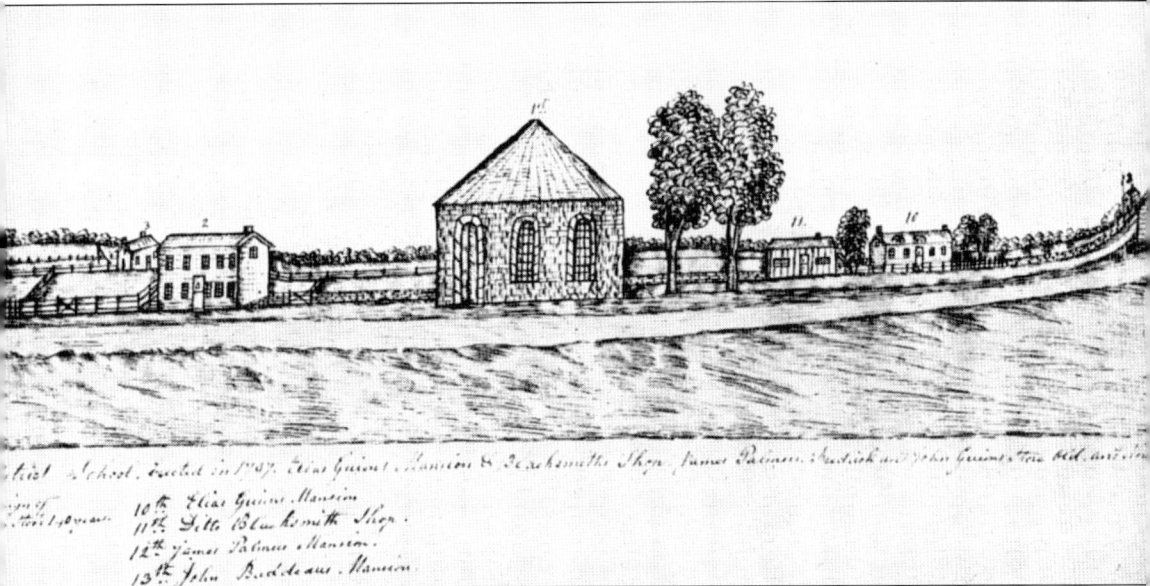

The homes identified with names of the first Huguenot settlers are clustered near the round church with a pyramidal roof that was patterned after a church in La Rochelle, France. In the 1689 deed for the 6,000 acres he sold to the Huguenot settlers, John Pell granted an additional 100 acres "for the sake of the French Church erected, or about to be erected, by the inhabitants of the said tract of land." The stones for the church that is pictured were laid in 1710. Some are now embedded in the bridge situated in front of the Thomas Paine Cottage.

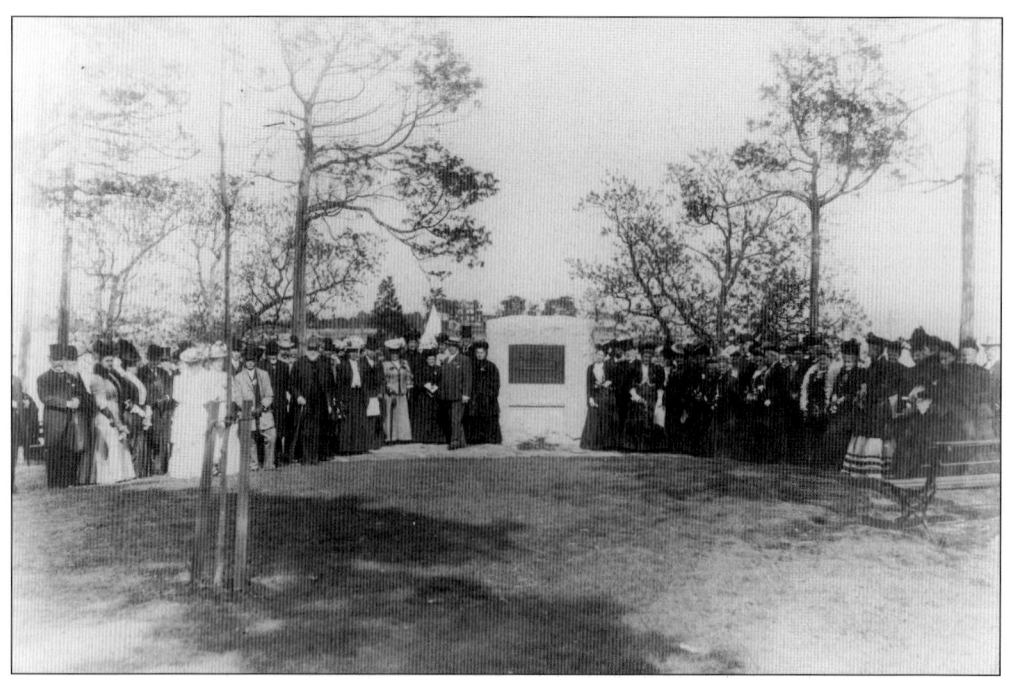

Overlooking Echo Bay, a memorial was placed "to commemorate the coming of the Huguenots" in 1898. A highly respectable crowd gathered in 1909 to rededicate the tribute of the Huguenot Association of New Rochelle and the Westchester County Historical Society. The next year, a wrought-iron fence was installed to protect the historic spot. For New Rochelle's 250th anniversary celebration in 1938, the memorial earned an updated plaque, listing the 151 "French Huguenot Family Names Identified with the History of New Rochelle Prior to 1750." Another appropriately grand event was held.

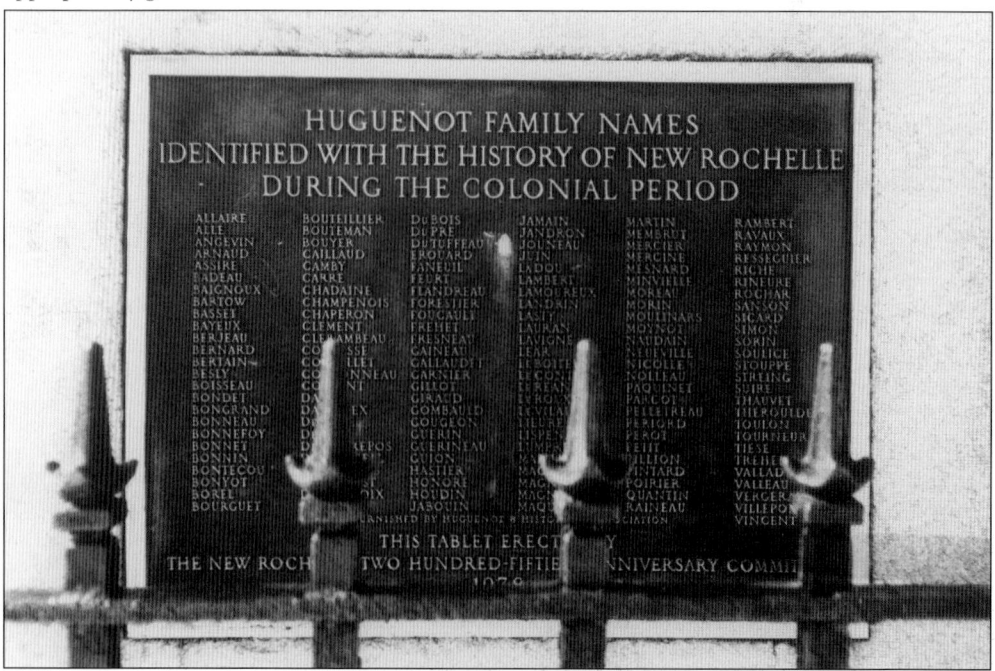

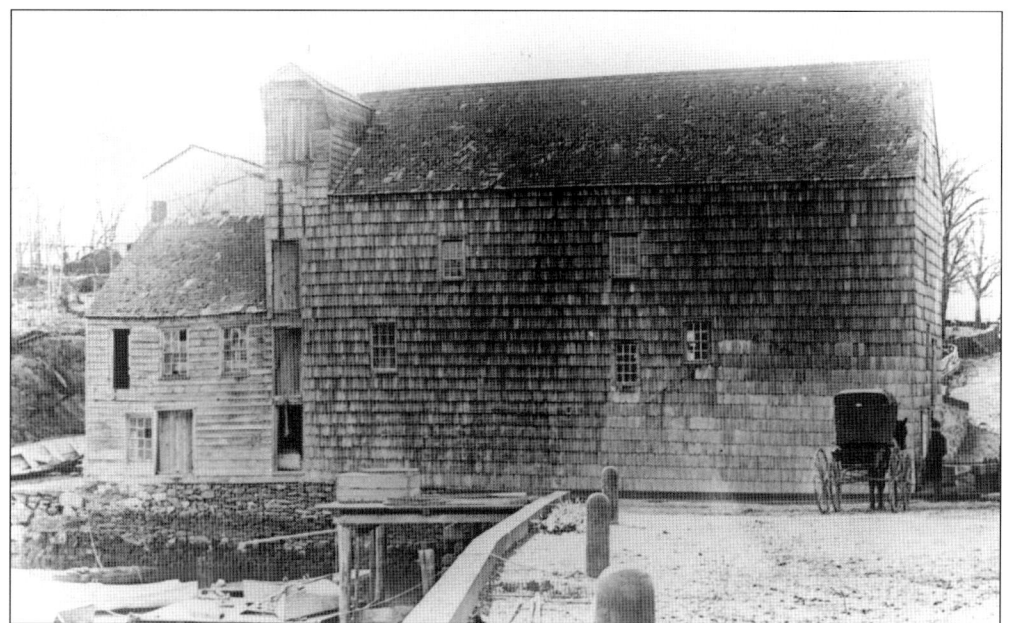

Paddle mills powered by tidal waters or river currents turned the early settlers' crops into goods for local use and for export. Precursors to steam and motorized engines, the mills could grind grain, saw lumber, press fruit, or pulverize charcoal. The Lispenard-Titus Mill operated from 1724 until the early 1800s, when the Erie Canal led to the demise of the milling industry on Long Island Sound.

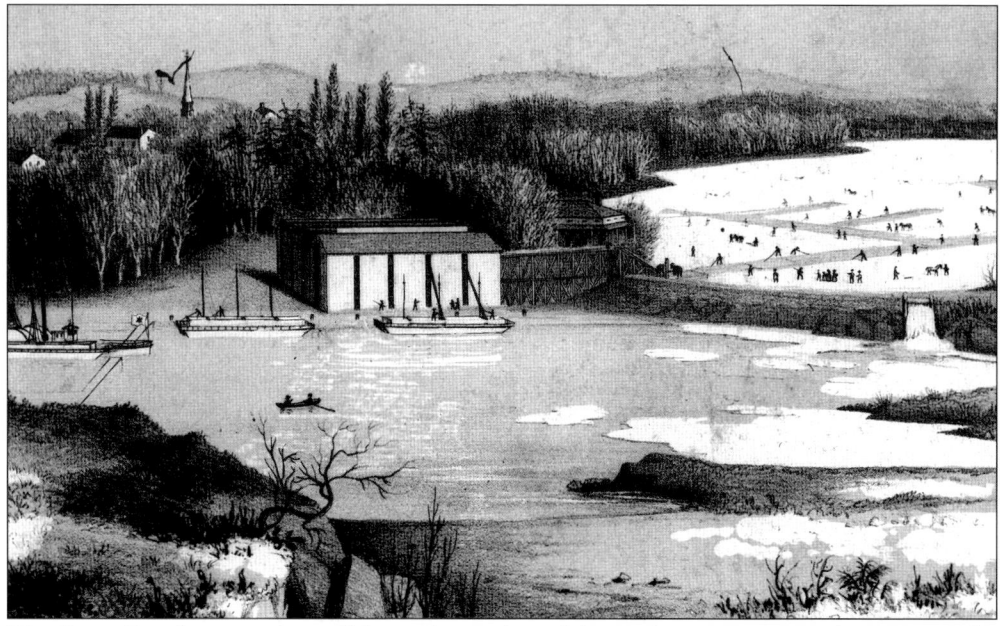

The Stony Brook powered a mill located on a large lake in the eastern part of town near the Boston Post Road and Long Island Sound. First producing lumber then cornmeal, the mill eventually churned out 8,000 bushels of wheat per month. Later from 1840 through the 1860s, an ice-making business that operated on the brook's Crystal Lake provided the majority of ice to Manhattan and Brooklyn. (Westchester County Historical Society.)

13

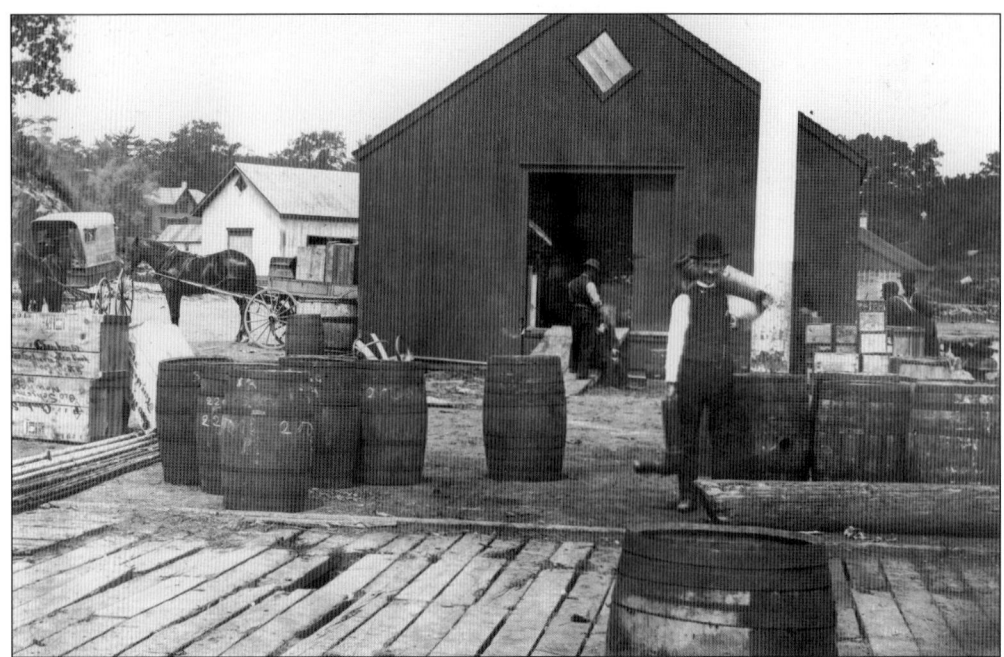

For nearly two centuries, a dock off Pelham Road was the primary site for the loading of products and crops onto boats for shipment to Manhattan. It also served as the first steamboat landing. When the town acquired Hudson Grove in 1886, a private dock became the town dock, handling the exchange of goods from vessels in Echo Bay.

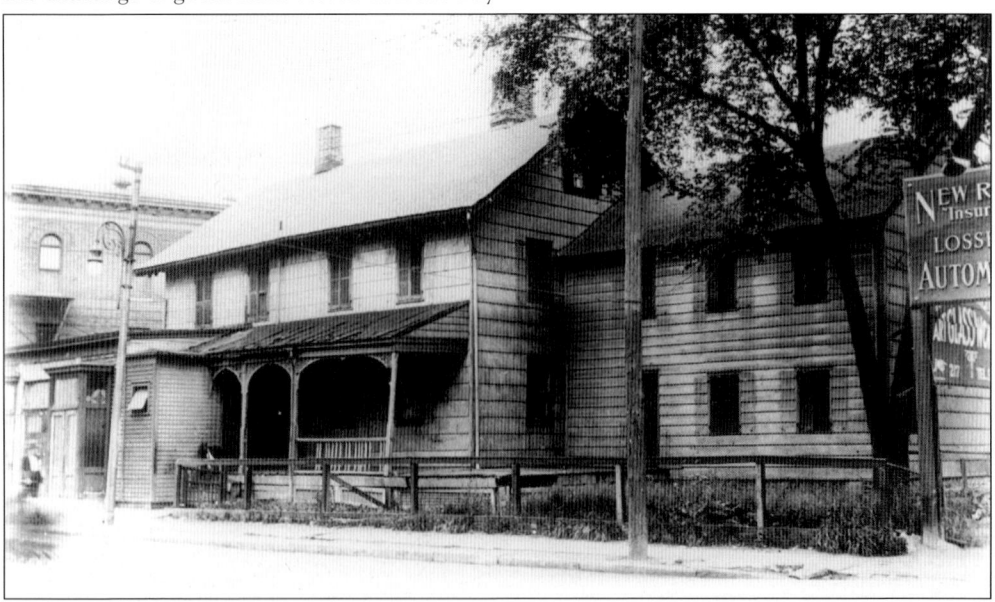

Taverns along the Boston Post Road offered travelers lodging, food, and drink. They also provided critical meeting places for town functions and for the exchange of news from afar. Intermittently from 1772 to 1815, meetings, trials, and elections were held at Besly's Tavern, a stagecoach stop on the northeast corner of North Avenue and the Boston Post Road. This photograph was taken shortly before the tavern was razed in 1928 for the construction of the Schiff (now referred to as the K) building.

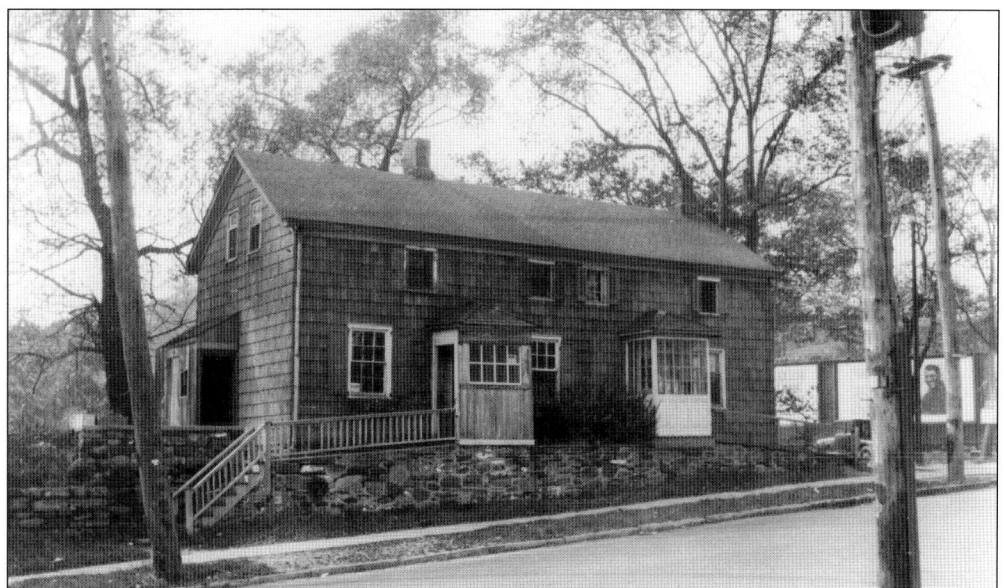

The Westchester Turnpike, which cut a straight-running Main Street alongside the old Boston Post Road (Huguenot Street) in the early 1800s, required payment for each kind of livestock or horse-drawn vehicle passing through, except for those carrying churchgoers on Sundays. Money was collected by the keeper of the tollhouse at Everett Street.

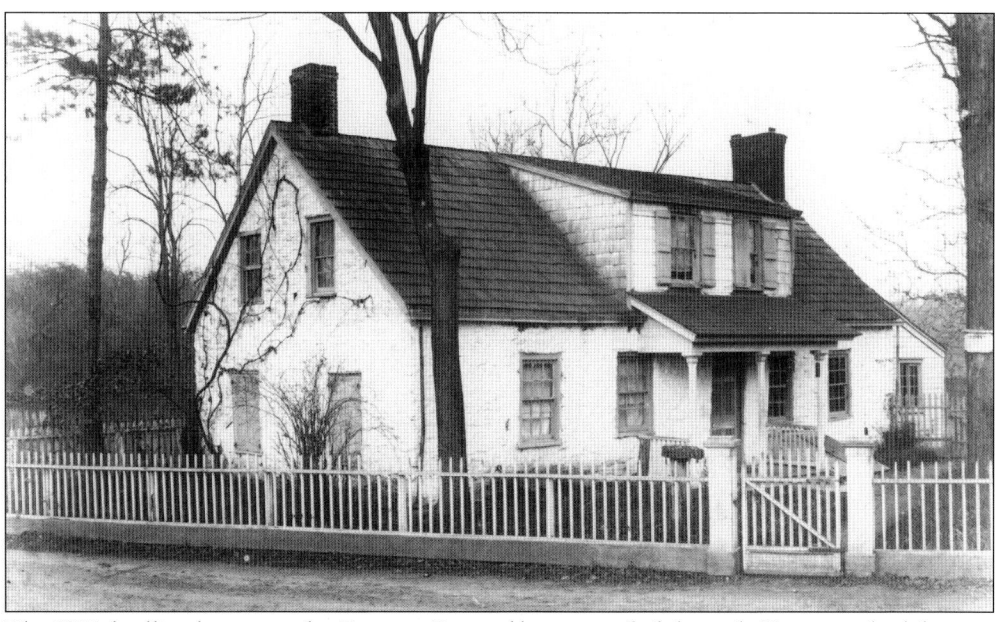

The 1726 dwelling known as the Coutant-Seacord house typified the early Huguenot-built homes. Patterning them after the houses of their homeland, the French settlers used stone for their sturdy one-story dwellings with lofts. The chimneys were usually situated at the gable end of the roof. Jacob Coutant, a well-known chair maker, lived here in the late 1700s; the Seacords were here until the late 1800s. The house stood on North Avenue near Brookside Place until 1927.

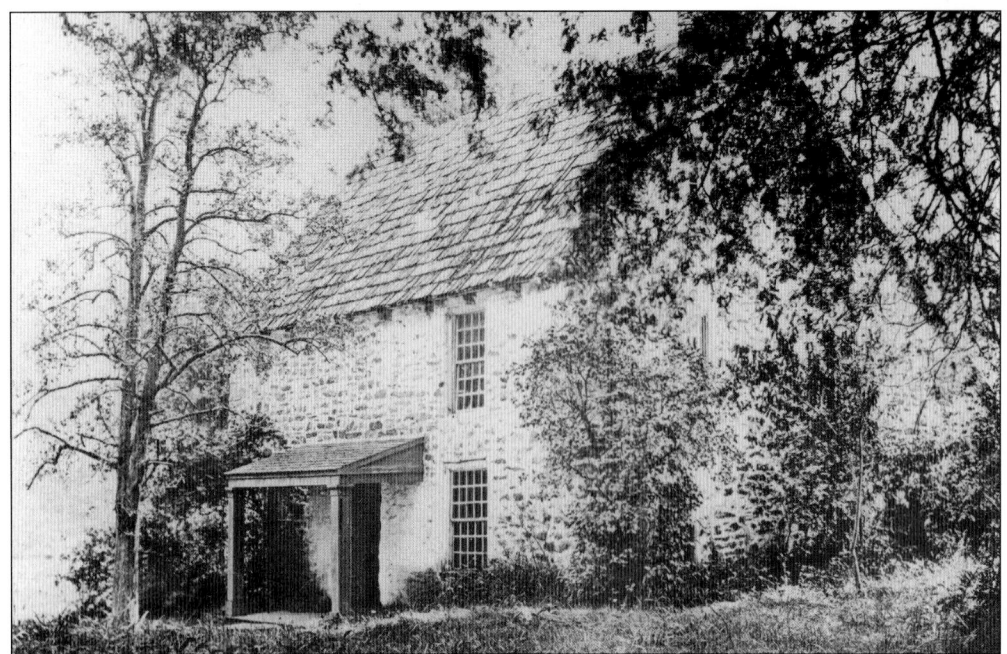

Louis Guion's blacksmith shop was located near Stony Brook as early as 1703. This building, the Guion-Allaire house, was built nearby early in the 18th century and stood until 1875, when it was torn down by its owner Lawrence D. Huntington. Later the naval reserve armory rose on the property near the east junction of Main and Huguenot Streets.

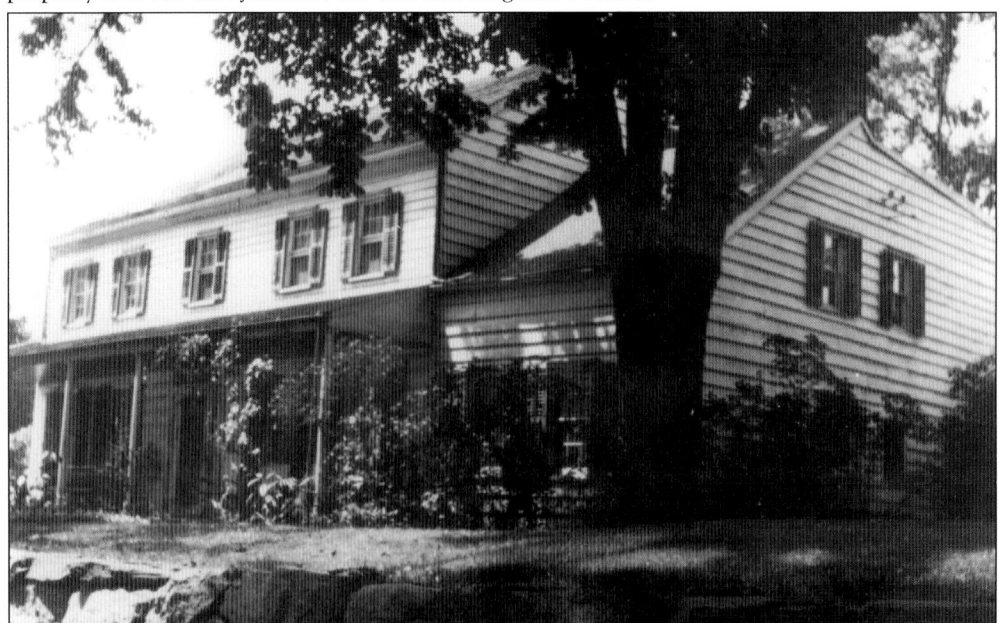

Huguenot homes, like one built by Moses Clark in the 1770s, were often passed down from generation to generation. Through each era, his descendants, the Clarks, Seacords, and Berrians, tailored the house to their families' needs. The Clark-Berrian house at 1120 North Avenue has grown considerably from its original one-story structure but retains its 19th-century farmhouse character and materials.

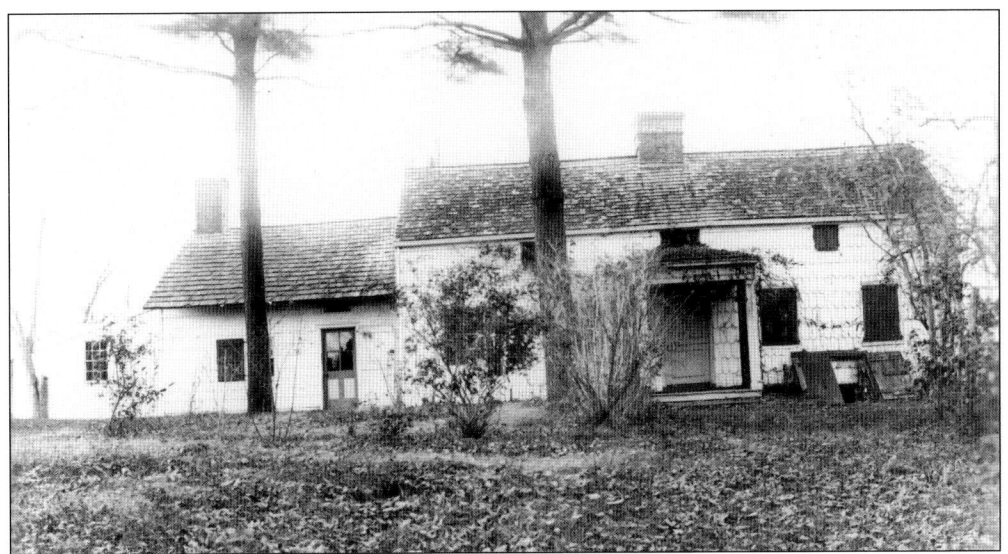

Eight generations of the Parcot family lived in a home near the northwest corner of Clove and Eastchester Roads, and the family's ownership of the land can be traced to 1714. Although greatly altered, the Parcot-Drake house still stands today, situated catty-corner on Clove Road, with some original sections dating back to the mid-1700s.

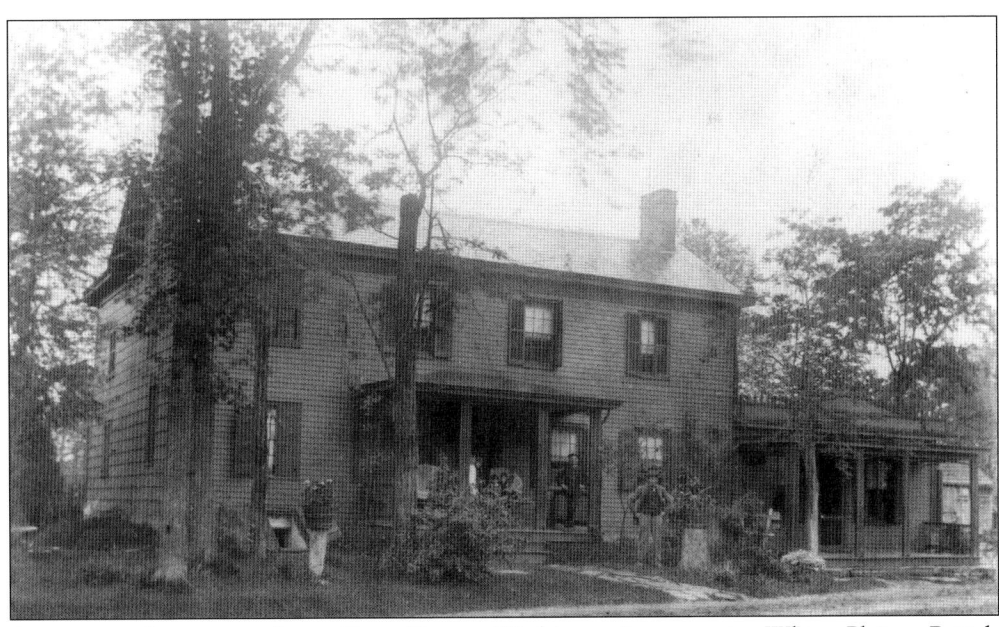

Awaiting orders to confront Gen. George Washington's troops in White Plains, British commander William Howe and some of his troops are believed to have occupied the home of Israel Seacord, strategically located on the "Road to White Plains" (North Avenue). Still situated at the corner of Quaker Ridge Road, the Israel Seacord house has been updated over the centuries but retains its historic integrity, a daily reminder of New Rochelle's early years.

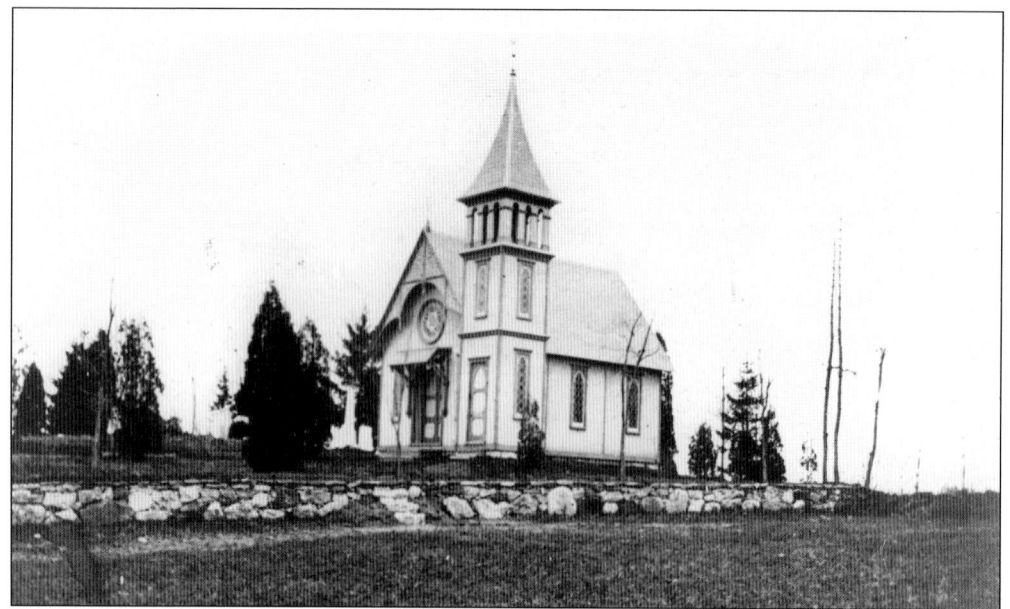

In the lawless days leading up to the battle of White Plains when Hessian soldiers raided the scattered farms of New Rochelle and British troops advanced toward White Plains, Isaac Coutant's mother died. Unable to travel to the Huguenots' burial grounds in town, he buried her near his farm on Webster Avenue. The family cemetery has continued since October 1776, although it is no longer graced by the small white chapel.

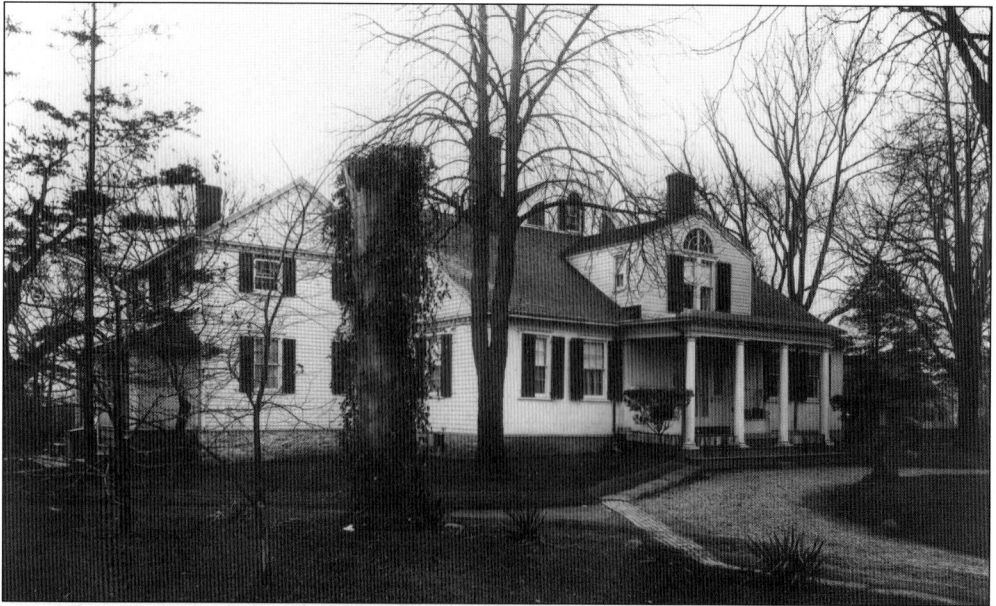

Huguenot descendant Pierre Vallade, a prominent merchant in New York, built a home for his family in the late 1760s. Following his death in 1770, his widow married Lewis Pintard, a newspaper publisher, businessman, and leading patriot during the Revolutionary War who earned commendations from Gen. George Washington. The Pintard house has served as the manse to the Presbyterian church and was listed on the National Register of Historic Places in 1979.

One of America's most forward-thinking and convincing writers of his time, Thomas Paine was gifted from the State of New York a 277-acre farm in New Rochelle for his contributions to America's long-sought independence. The property, confiscated from a loyalist, extended from what is now North Avenue to the border of Mamaroneck. Paine lived here from time to time, beginning in 1803 until 1806. His hillside cottage is pictured here with later owners.

Paine was first memorialized in New Rochelle with a 12.5-foot-high monument designed by John Frazee that was dedicated on November 9, 1839, at the foot of Paine Avenue. The bronze bust sculpted by James Wilson McDonald was added on May 30, 1899. The Paine monument was rededicated and gifted to the City of New Rochelle on October 14, 1905.

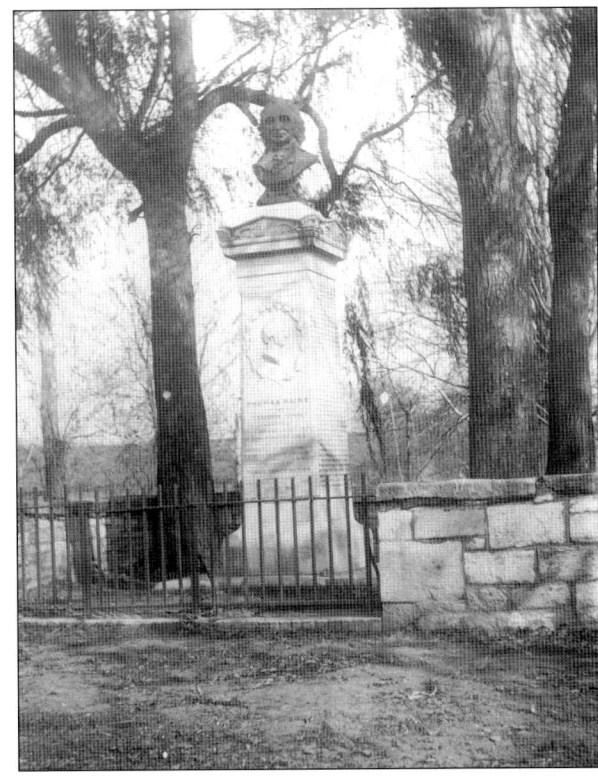

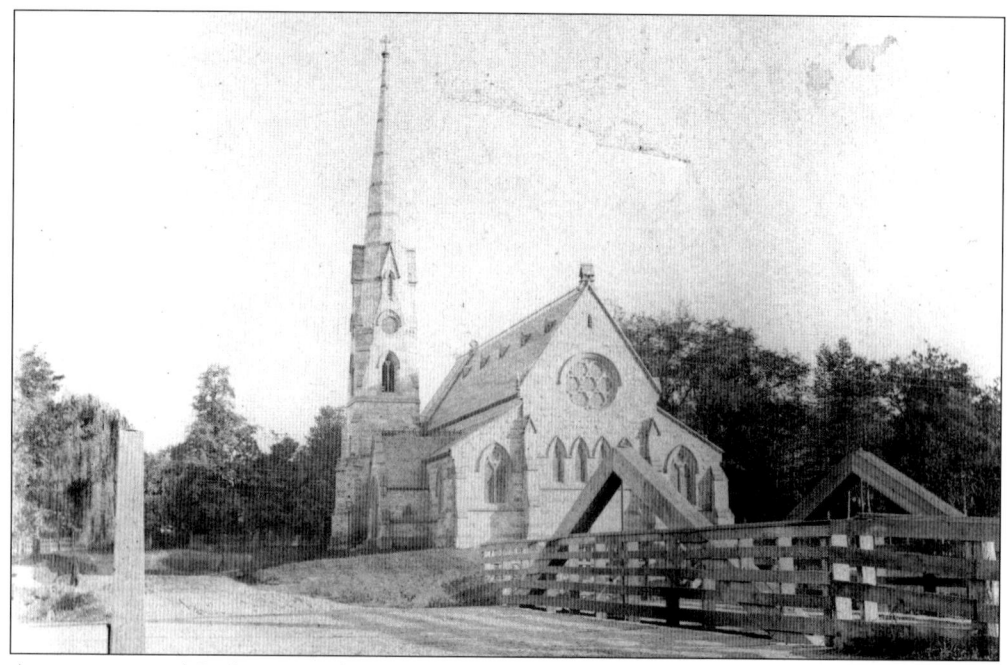

A masterpiece of Gothic Revival ecclesiastical work, Trinity Church was designed by celebrated architect Richard Upjohn as the third home for the congregation that began with the Huguenot settlement. The rough-faced granite structure topped with a graceful spire was completed in 1863 at the corner of today's Huguenot and Division Streets.

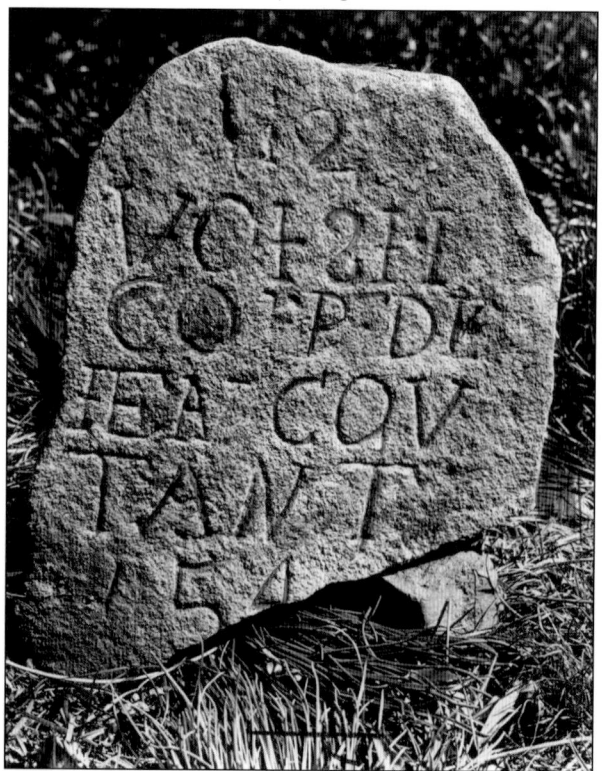

The 18th-century tombstone of Jean Coutant, in French, originally marked a grave site in the Huguenot Burial Grounds, located near the center of the early town. Graves were twice reinterred, first for a parkway that was not constructed and then for the building of Interstate 95. A memorial, a few rough stones, and the Allaire family cemetery are now located adjacent to the Trinity Church cemetery. Both Trinity–St. Paul's Episcopal Church and the Huguenot Burial Grounds were listed on the National Register of Historic Places in 2006.

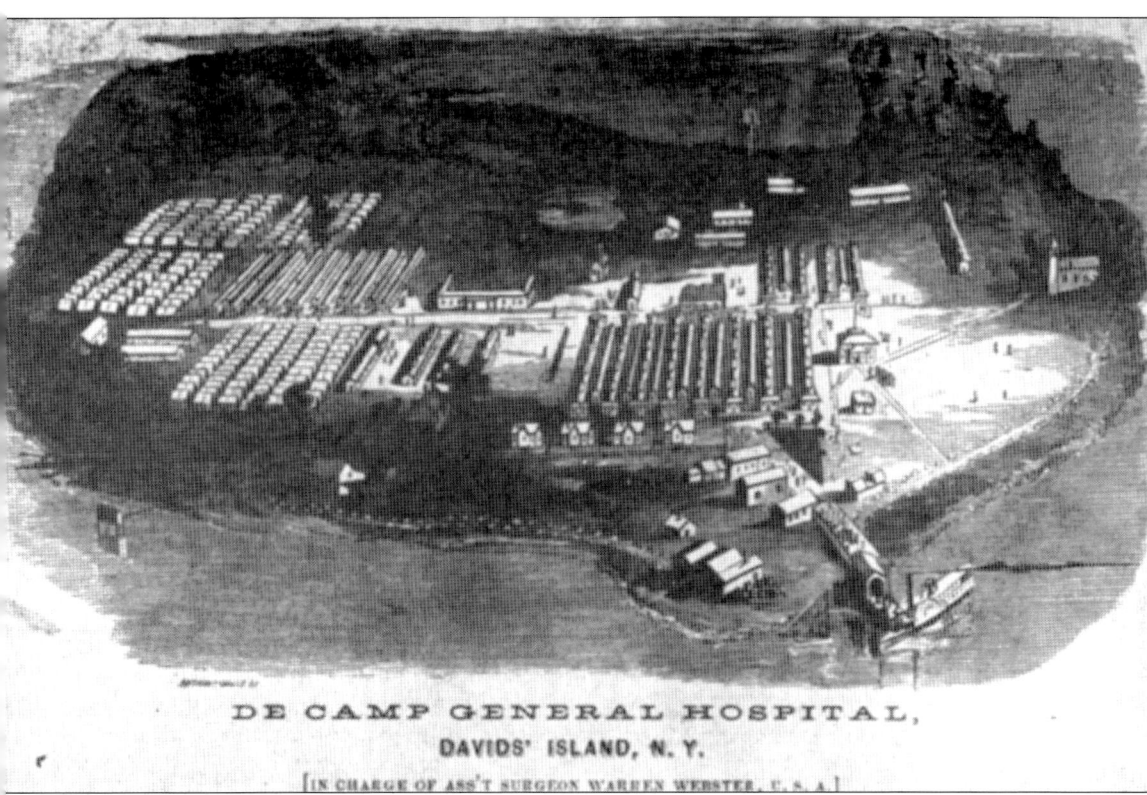

DE CAMP GENERAL HOSPITAL, DAVIDS' ISLAND, N. Y.
[IN CHARGE OF ASS'T SURGEON WARREN WEBSTER, U. S. A.]

At the height of the Civil War, Thaddeus Davids leased his island to hotelier Simeon Leland, who then signed a lucrative lease with the federal government. DeCamp Hospital was erected in 1862 and treated thousands of wounded Union and Confederate soldiers who were ferried out to the island from New Rochelle. Round-the-clock sentry guards who were poised to shoot escaping prisoners could be seen from New Rochelle's shores. (Westchester County Historical Society.)

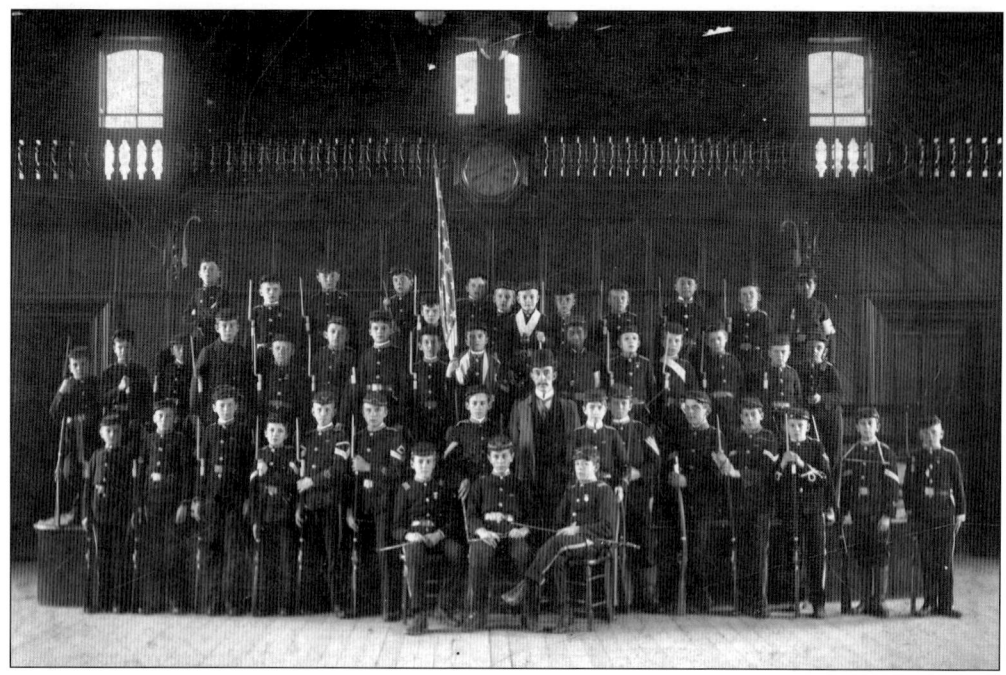

During the Civil War in 1861, the New Rochelle Cadets were established for home defense. Several joined 2nd Lt. Henry W. Clark in becoming members of Company G, 17th Regiment, National Guard, New York State. Clark became captain for the unit, which served for 30 days at Fort McHenry in Baltimore, Maryland. On their return, there was a grand party in their honor hosted by the women's auxiliary of the Grand Army of the Republic (GAR), pictured here at Cadet Hall on Centre Avenue near Main Street. The junior GAR is pictured above.

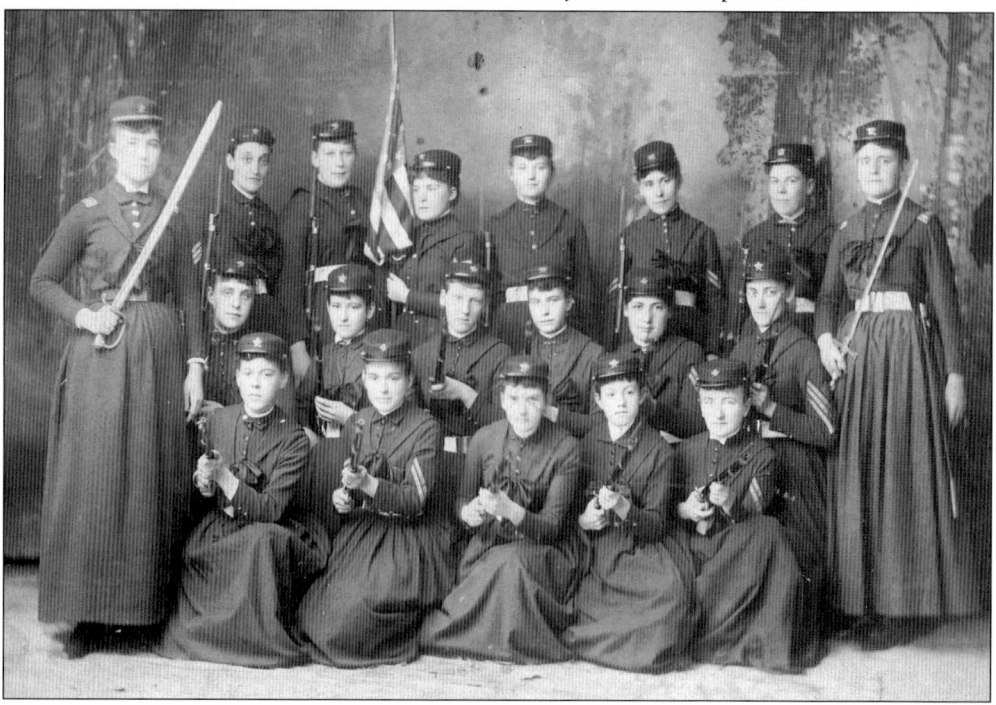

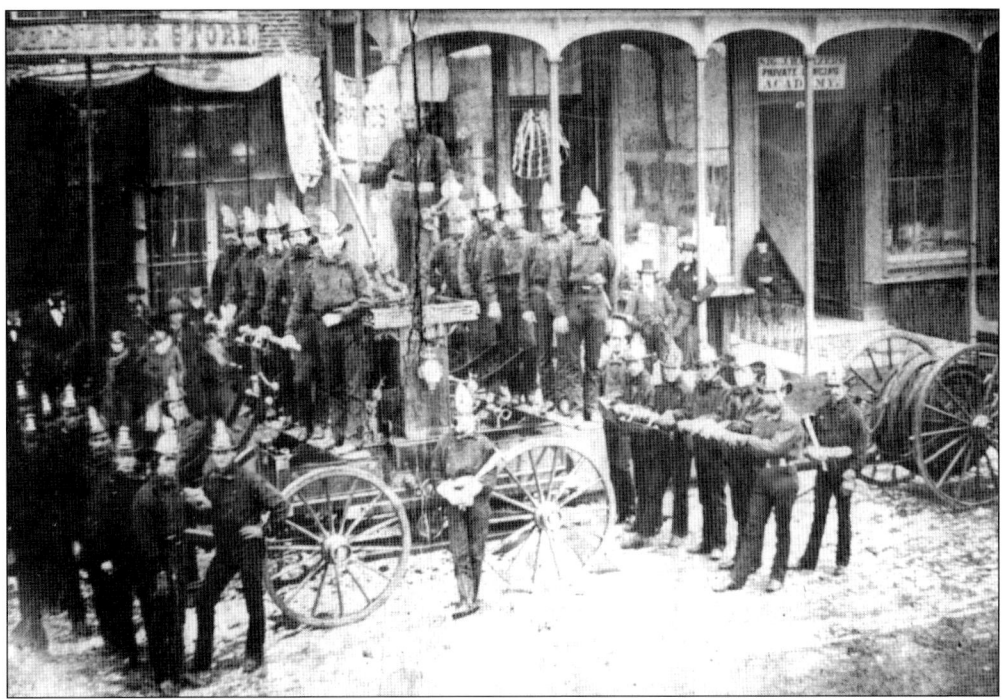

New Rochelle's fire service began at the time of the Civil War, when the community was comprised of about 3,500 people. Starting as two separately established volunteer fire companies—the Enterprise Hook, Ladder and Bucket Company (above) and the Huguenot Hook and Ladder Company (below)—the fire service for the town of New Rochelle and the village it encompassed eventually boasted six fire companies.

New Rochelle's first train depot was a charming gingerbread-style building that stood on the northeastern side of the North Avenue bridge above the tracks. Built soon after passenger rail service began in 1849, the site of the station was later moved to the level of the tracks, and the current station was constructed around 1886.

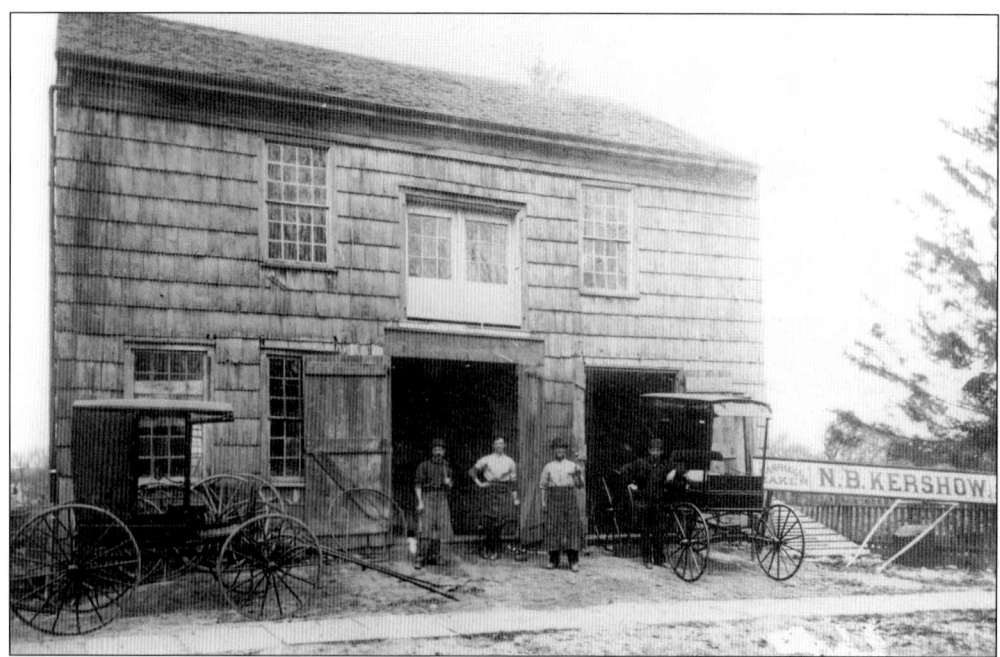

Near the railroad tracks and station, N. B. Kershow's shop thrived at 29–31 Lawton Street. The carpenter, blacksmith, painter, and craftsman purchased this wagon-making shop and carriage house from John and Walter LeCount, Huguenot descendants. After his death in 1905, the "high class of carriages" continued to be manufactured by his sons William B. and L. V. Kershow.

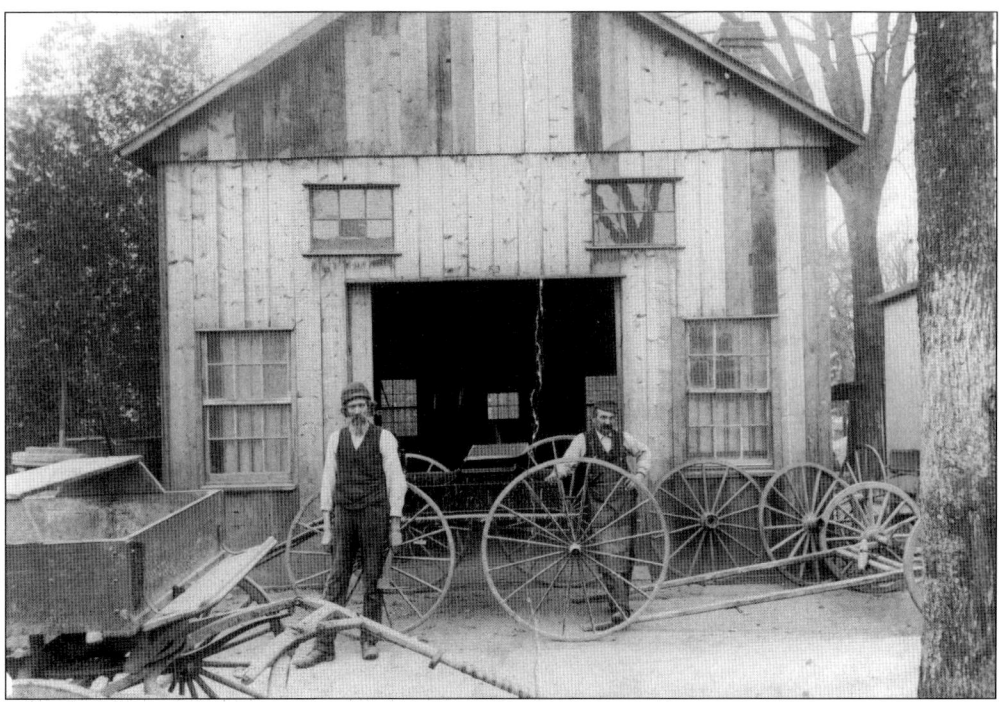

John E. Seacord's blacksmith shop (above) and Morgan's Livery Stable (below) were conveniently located near each other on Lawton Street, as shown in these 1880 photographs. It was a busy thoroughfare, also housing the offices and printing presses of at least three local newspapers. The 1897 New Rochelle Pioneer Building is standing today and was listed on the National Register of Historic Places in 1983.

When the bell rang from atop this building each morning, 800 white children who had walked from all corners of New Rochelle entered the doors of Trinity Place School. When it opened in 1884, it was declared the "best school building in the county." It replaced an 1856 school that burned to the ground on the same site. The school was finally integrated in 1899.

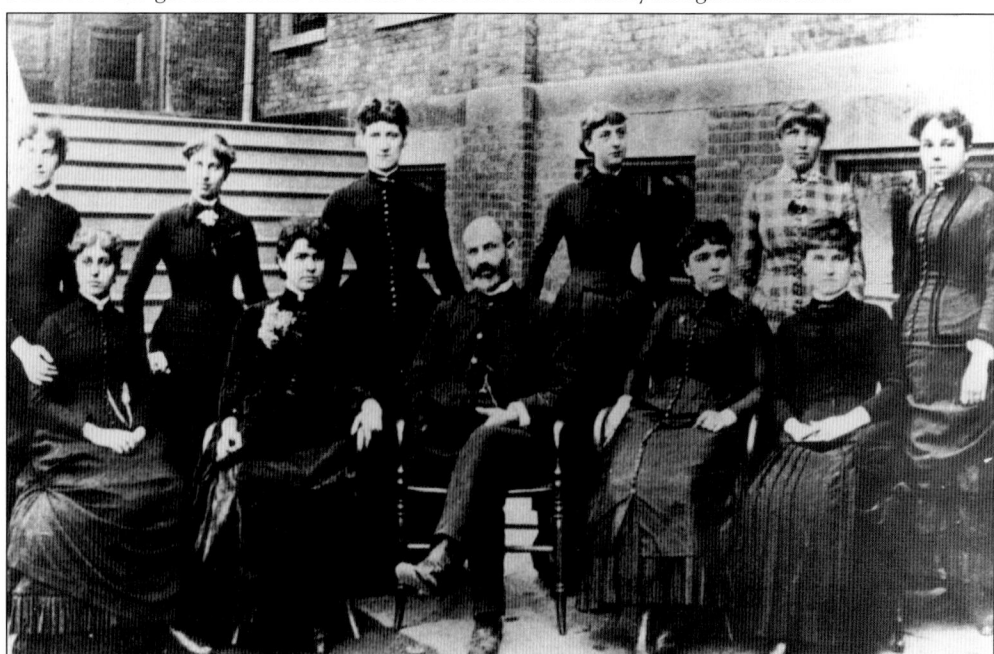

In 1880, Isaac E. Young, pictured here with Trinity Place School teachers, was appointed New Rochelle's first principal. Distinguishing New Rochelle as a leader in improving the educational system, the position of superintendent of schools was created in 1891 and filled by Young until 1907 when Dr. Albert Leonard took the helm.

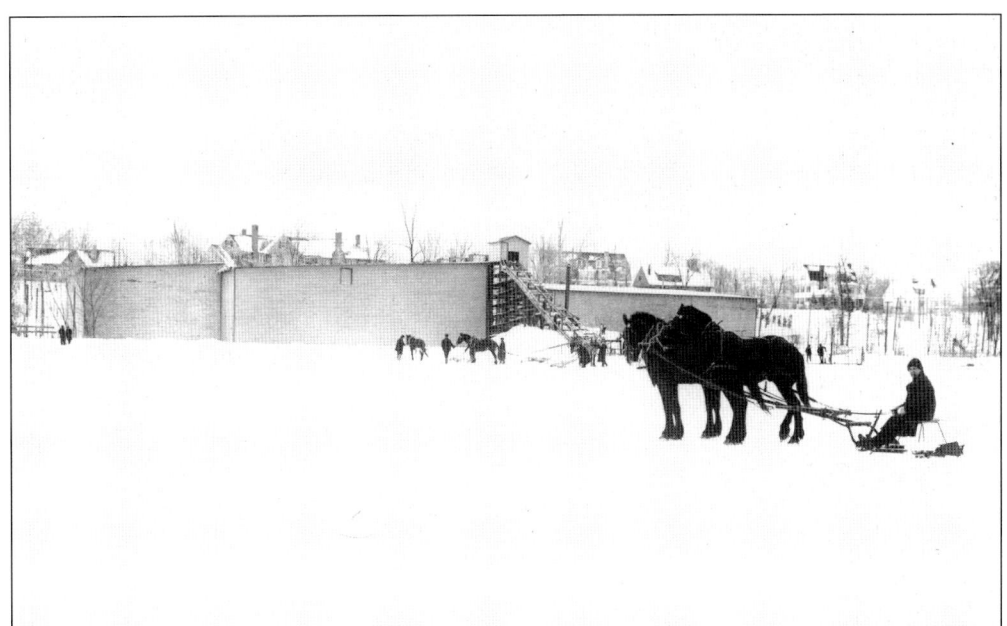

Frozen lake water was turned into a hefty profit by two generations of Mahlstedts, who harvested ice from their big lake at North Avenue and Eastchester Road. After refrigeration made their once-lucrative business obsolete, the Mahlstedts sold their lake and adjoining property to the City of New Rochelle in 1922. The 40 acres soon boasted a new high school, a branch of the library, and a park with a causeway forming twin lakes.

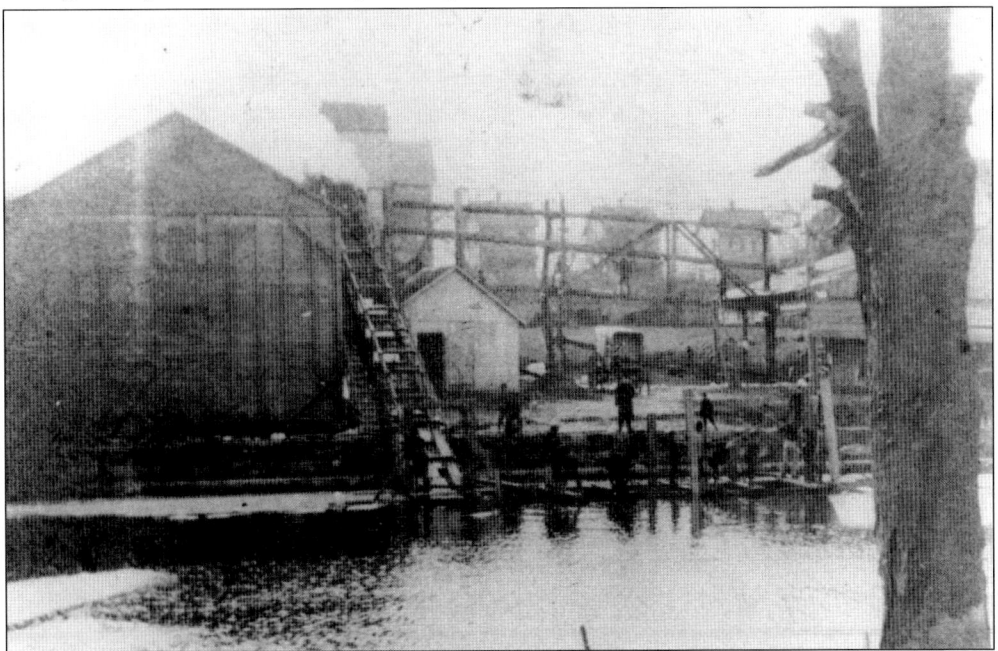

A 1905 photograph of Frank J. Holler's ice pond at Fifth Avenue and Halcyon Terrace shows the large building where the ice blocks were packed in hay for insulation. New Rochelle had five or six ice businesses in the 1800s. The smaller enterprises furnished New Rochelle households; the larger also shipped their product to Manhattan.

27

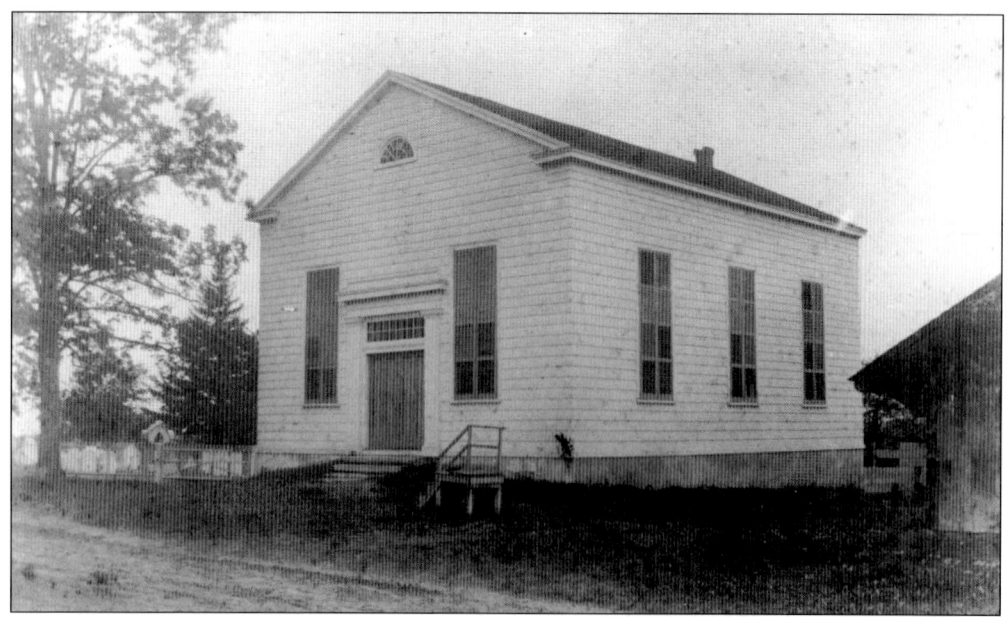

A sliver of the Israel Seacord farm was purchased by one of the region's earliest Methodist congregations for the construction of its first church in 1788. Its 1838 wood-frame replacement (above) burned in 1897. The third building of the First Methodist Church, dedicated in 1898, was stone. Architectural critic Montgomery Schuyler, writing anonymously in the 1909 issue of the *Architectural Record*, called it a "gem of rural church architecture . . . in perfect congruity of the whole with its surroundings." Still standing at 1228 North Avenue, it was purchased by Young Israel of New Rochelle in 1966.

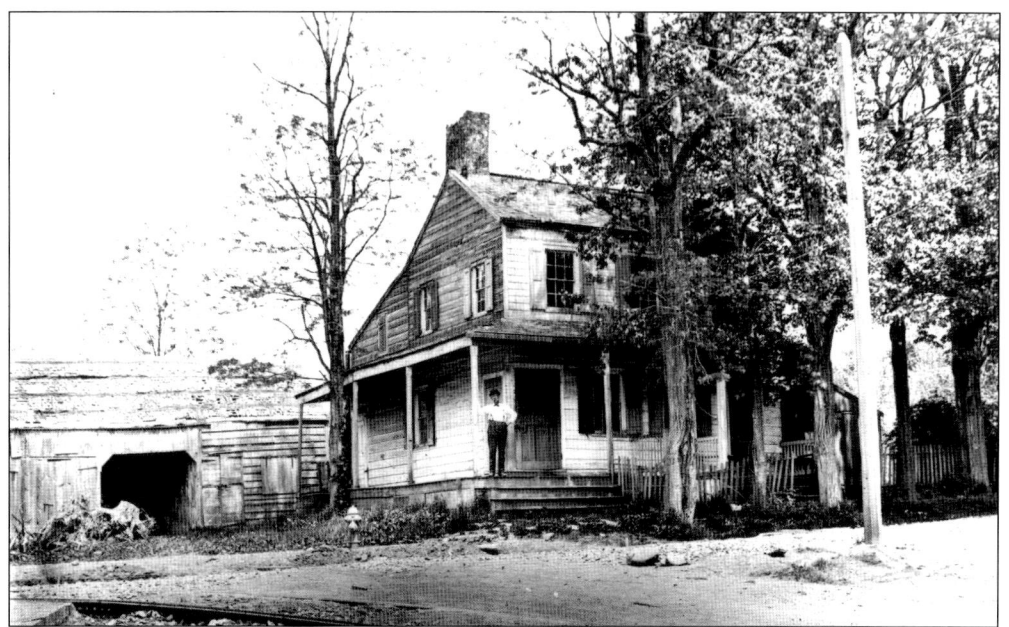

For over two centuries, Cooper's Corners served as an outpost for the residents who lived in Upper New Rochelle miles from the downtown hub. The hamlet took shape at North Avenue and Mill Road near Burtis Mill that was powered by the Hutchinson River. It eventually included the general store of John Cooper, pictured here, the 1795 Cooper's Corners School, the 1859 St. John's Wilmot Church, and the 1901 Wilmot Fire Station No. 6.

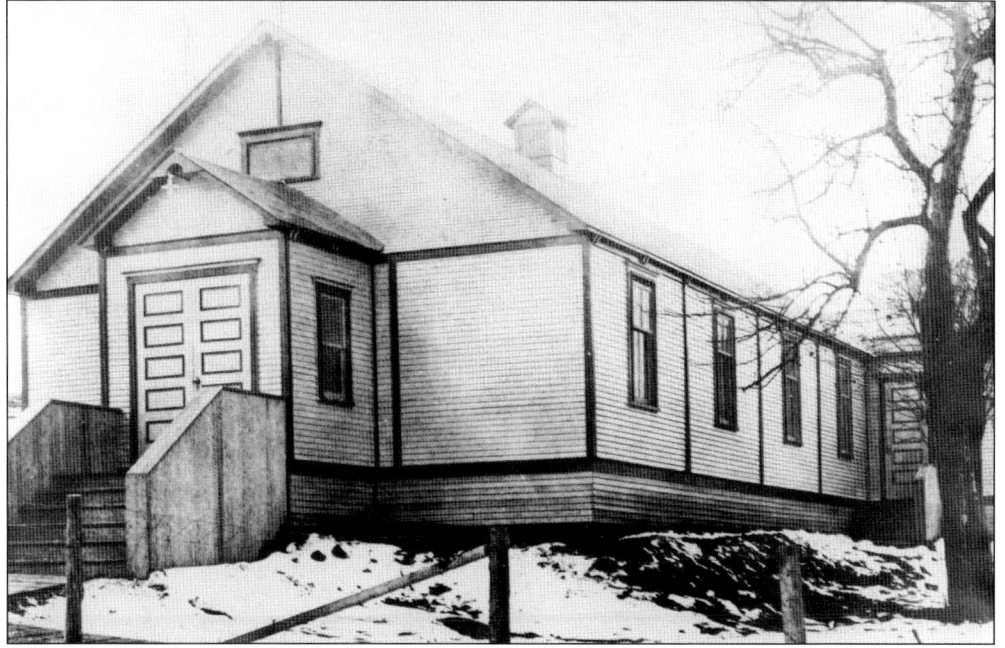

When a 1795 act of state legislature provided the first funding for public schools, one of the first three schools established in the community was the Cooper's Corners School. Children living in the very northern section and parts of Eastchester attended the school in the one-room building until Roosevelt School was constructed in 1920. It is now used as a private nursery school.

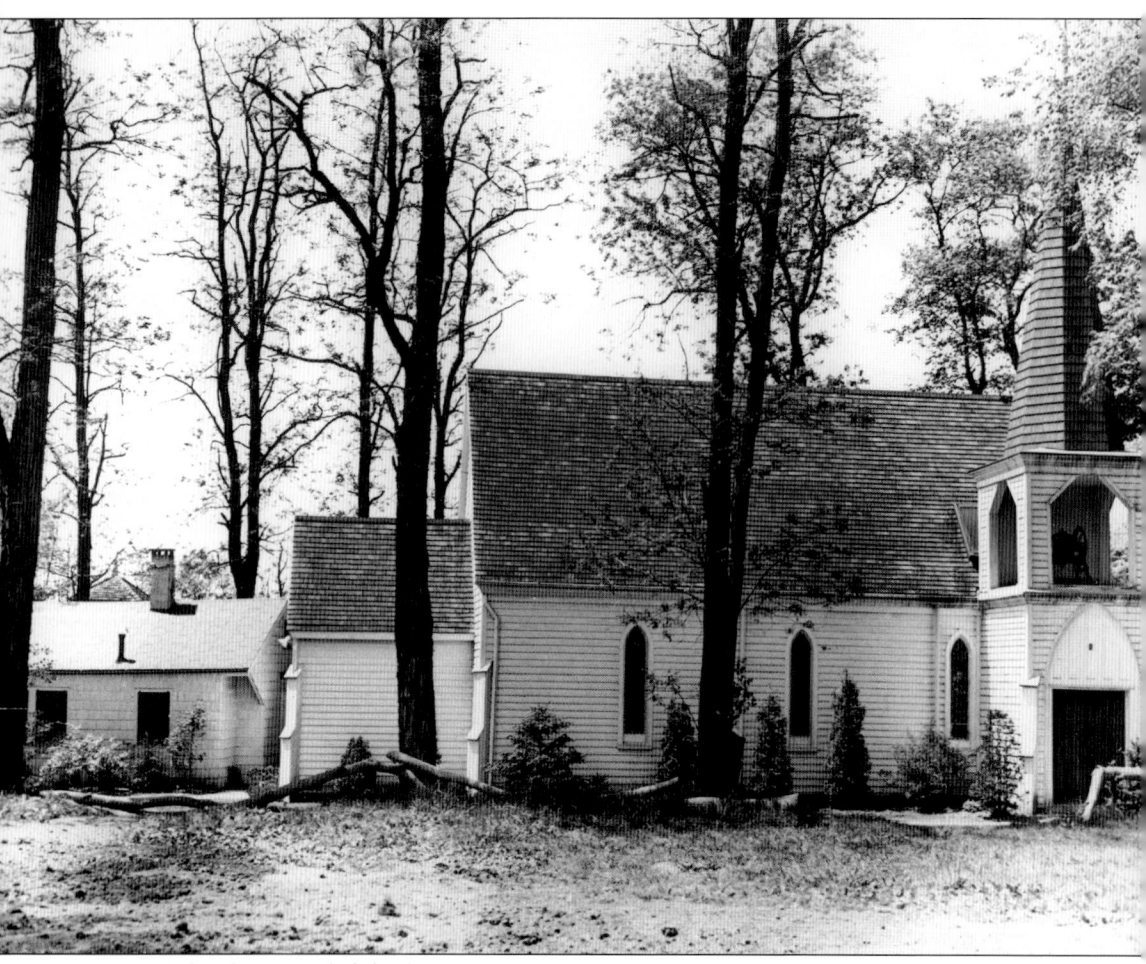

Twenty families attended the first service in the newly built St. John's Wilmot Church in February 1860. They had previously walked five miles from their farms in Upper New Rochelle to attend services at Trinity Episcopal Church in the heart of town. St. John's Wilmot Church is now the oldest extant house of worship in New Rochelle, having been completed in 1859 at the corner of North Avenue and Wilmot Road.

Two

New Rochelle's Sound Resorts

An "arm of the Atlantic," Long Island Sound stretches along the New York and Connecticut shorelines to the ocean. The western end of the estuary meets Manhattan's East River at Hell's Gate. This waterway not only put New Rochelle on a trade route, it propelled the farming community into becoming a resort destination. Sophisticated entrepreneurs and the advancement of steamboat travel ensured its success, as developers and visitors were lured by the wide-open vistas, clean country air, and unlimited aquatic activities just a boat ride from the increasingly crowded and sullied streets of Manhattan.

All along the nine miles created by New Rochelle's irregular shoreline and islands, hotels and resorts, including one of America's first amusement areas, attracted wealthy and middle-class Manhattan residents. The steamboat *American Eagle* brought boatloads of visitors on runs between Fulton Street in New York City and New Rochelle's Neptune Island dock beginning in 1842. Four decades later, tens of thousands arrived each summer day on John Starin's side-wheelers for an outing at his Glen Island Resort.

Many who came for summer pleasures liked New Rochelle so much they planted roots for good. By the early 1900s, slim sculls, world-class yachts, and recreational sailboats filled the city's harbors that had once moored whaleboats, packet ships, and freighters. As neighborhoods began taking shape throughout the community, the recreational and social activities afforded by the shorefront parks and clubs were frequent selling points.

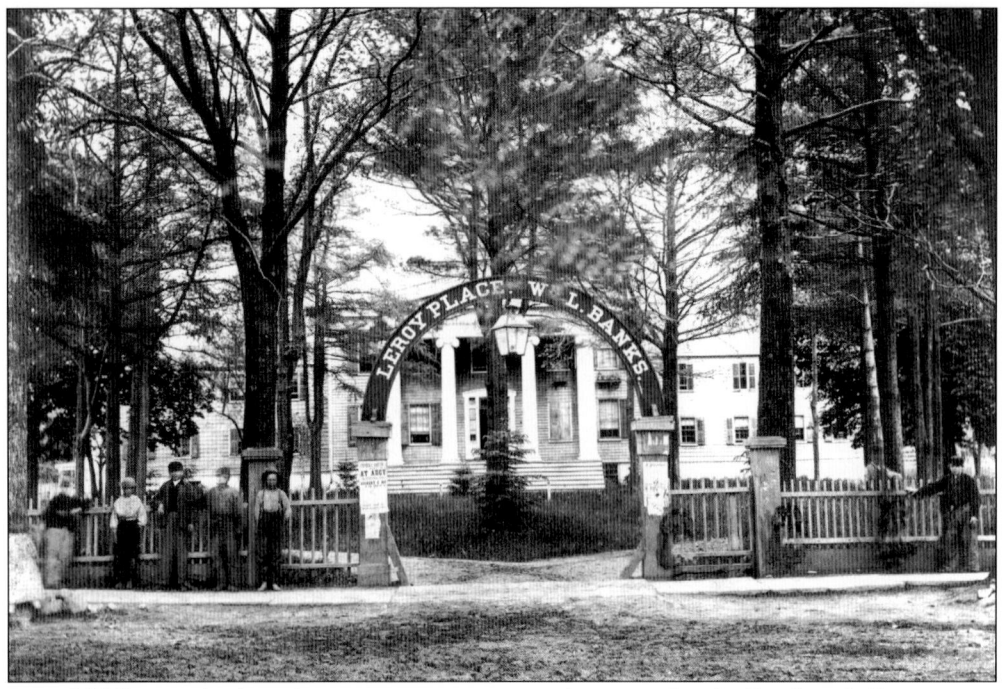

Daniel Webster, a leading American statesman, met his second wife, Caroline LeRoy, on one of his frequent stays at the LeRoy House, located on Main Street and Centre Avenue. LeRoy's father was the proprietor of the renowned, refined hotel before selling it to W. L. Banks.

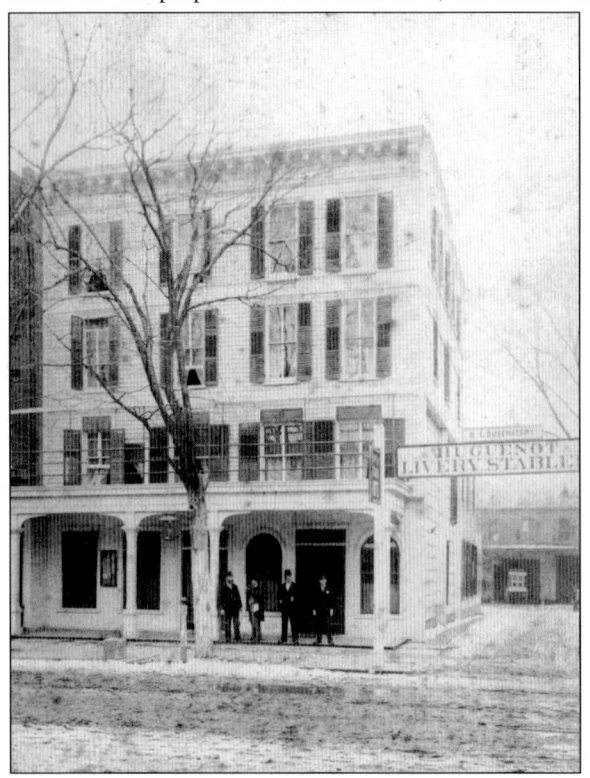

The Huguenot Hotel's upscale guests arrived by carriage, stagecoach, train, or steamboat. Located in the key location of Huguenot Street (the former Boston Post Road) and North Street (which became North Avenue in the early 1900s), this hostelry was well established by 1918 when this photograph was taken.

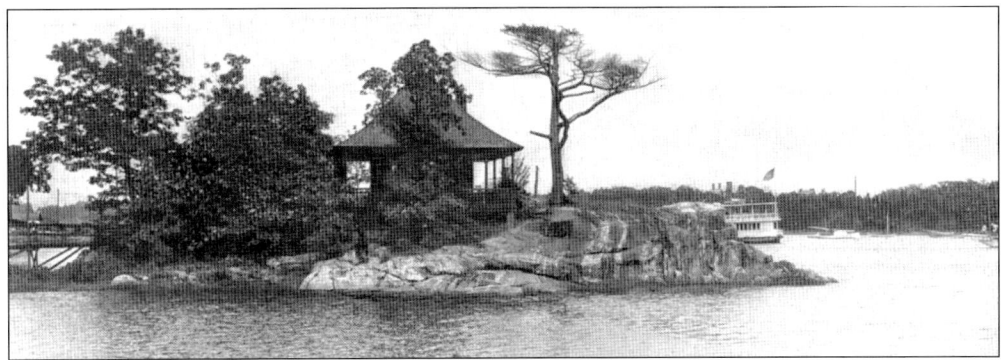

"Delightfully situated on Long Island Sound . . . about 18 miles from New York," began an advertisement of the Neptune House, one of the region's most important vacation spots. "In point of salubrity and picturesque scenery it is not surpassed by any in America." Perched on a hillside overlooking the lower end of New Rochelle Harbor, the resort entertained tens of thousands of guests who arrived primarily by steamboat, from 1838 to 1880. "The view from the hotel is unrivaled," Robert Bolton later wrote. From the verandas of the huge three-story hotel, the sweeping lawns introduced the "unspoiled panorama" of harbor, Davenport Neck, and a "seven-mile stretch across the Sound." After the resort closed due to waning steamboat travel, Adrian Iselin Sr. purchased the hotel and island it sat on in 1885. The hotel was torn down, but four houses on Harbor Lane were built with its timbers. In 1903, Iselin gifted the land to the City of New Rochelle to be used "exclusively for park purposes."

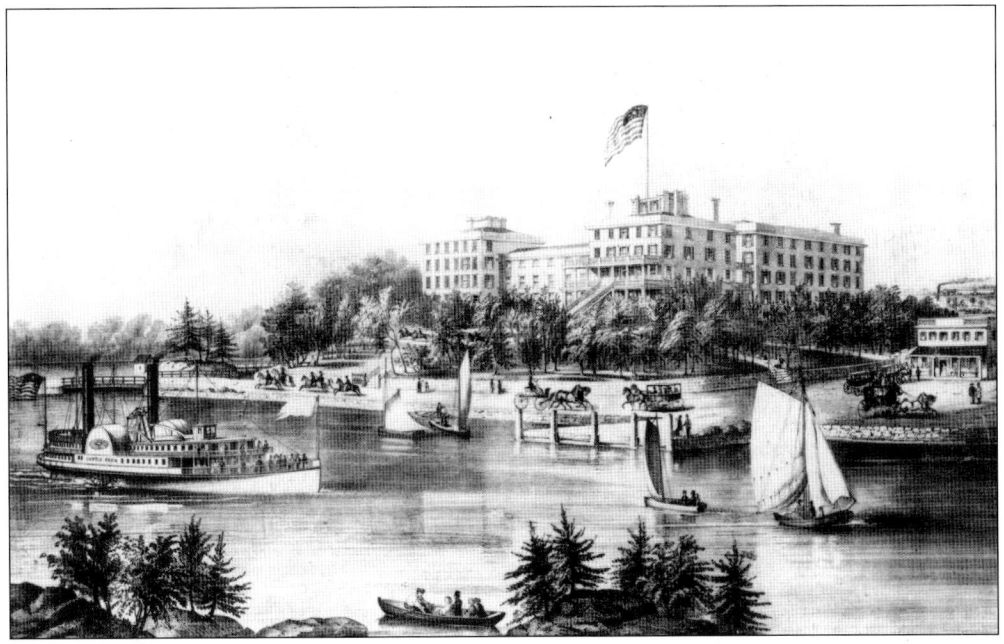

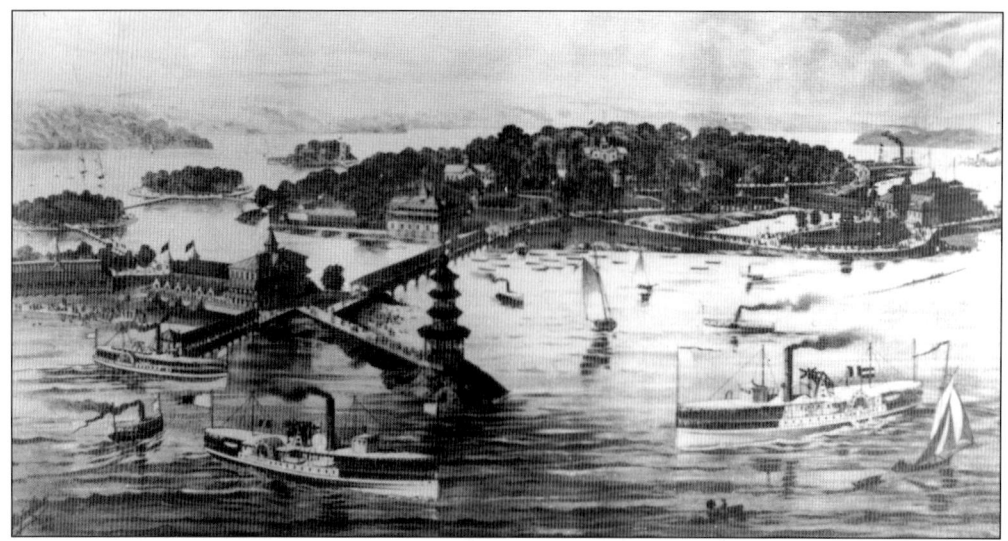

One of the earliest and most extravagant amusement areas opened off New Rochelle's shoreline during the summer of 1880. Within two years, over a half-million visitors each summer were soaking up the fabulous waterfront attractions offered at John Starin's Glen Island Resort, "the World's Pleasure Grounds." Starin, the owner of the largest fleet of steamboats in Manhattan, created a lucrative destination for his vessels.

Blending recreation and culture, Starin's resort included a beach and bathhouse for 2,000 people, ethnically themed villages, manicured gardens, fashionable restaurants, and dozens of other wholesome diversions for a "civilized" family excursion. Trolleys ran from the New Rochelle train station, and a ferry pulled by a chain brought visitors over from the mainland.

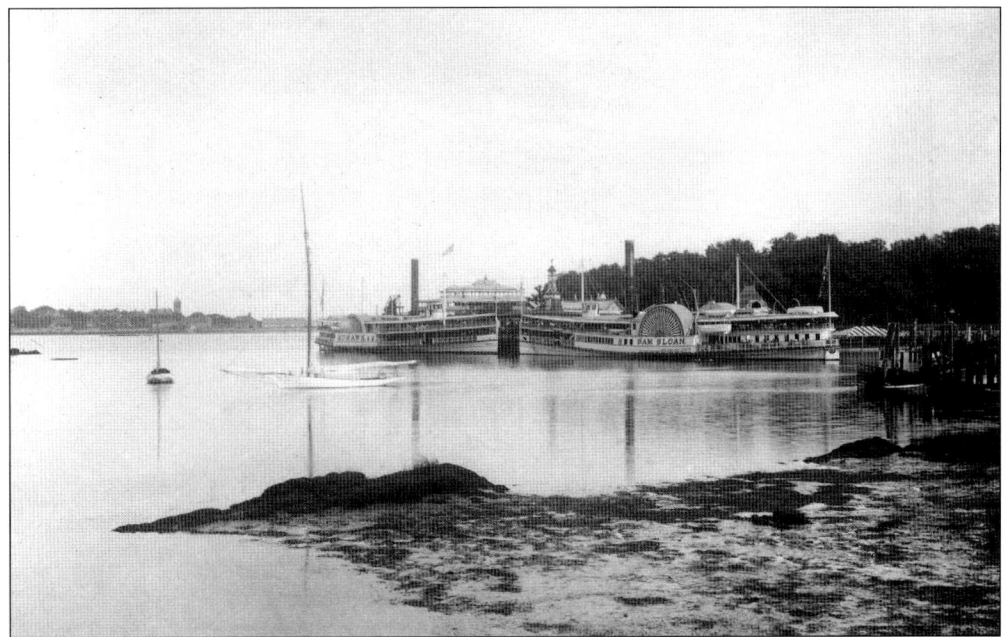

As the steamboats pulled into the docks of Starin's Glen Island Resort, chimes atop a Chinese pagoda rang out a welcome. The enormous crowds from New York and the locals who came by trolley or train to Neptune Island and to Glen Island by canoe, rowboat, or a ferry had a multitude of diversions from which to choose.

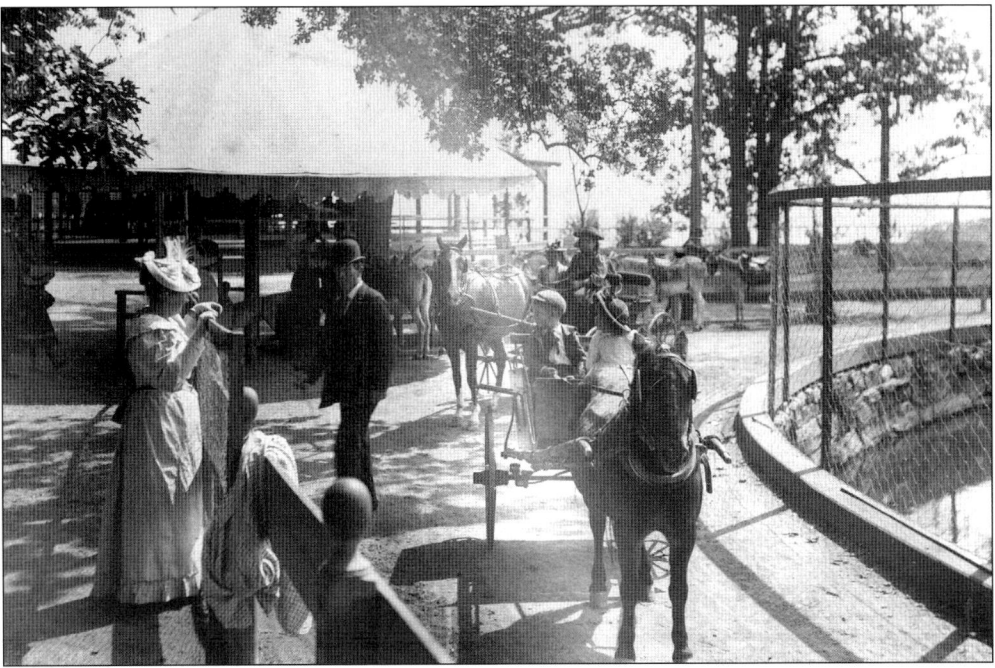

A total of 102 acres of property, the islands were connected by red-roofed footbridges and contained more than two dozen red and white striped buildings housing restaurants, game rooms, and other amusements. Starin was a great equestrian and introduced children to riding by offering donkey rides.

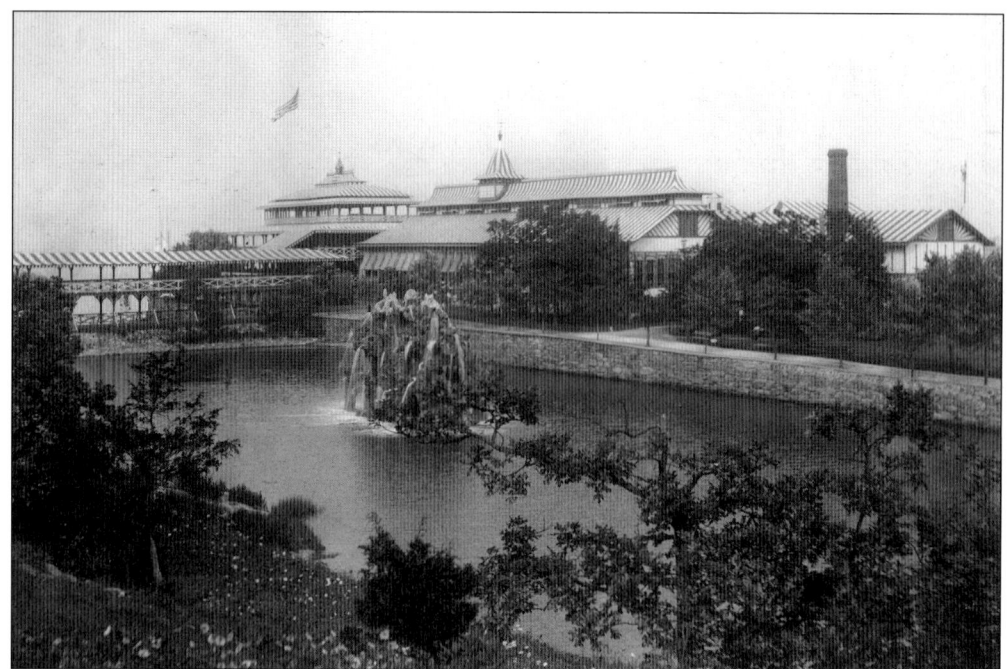

In the Grand Cafe, 3,000 diners could feast on a clambake costing $1 per person. A grotto featured trained seals. A zoo contained a house of monkeys, a popular little brown bear, lions, camels, and polar bears. An aviary held a brilliant array of plumed birds.

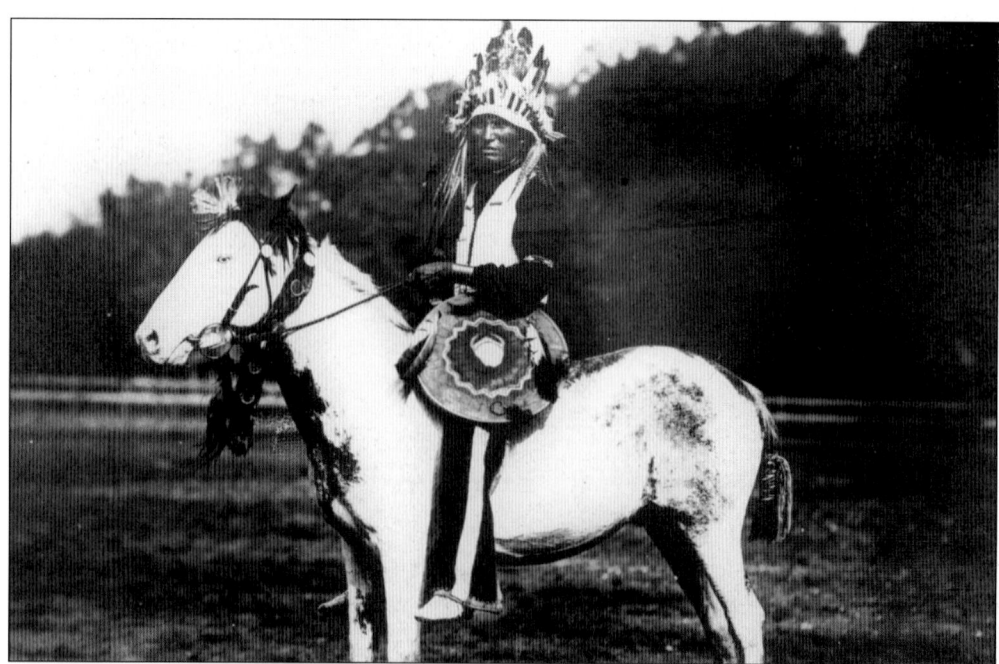

An entire Sioux tribe was brought to the resort in 1901. Chief Hollow Horn Bear, pictured here, was the ceremonial leader. A member of the tribe named her newborn girl Glen Island Goes to the Dance. The mother, named Lone Dog, had been dancing with the baby's father the night before.

In a castle John Starin fashioned after a Rhineland fortress, singing waiters in lederhosen poured New Rochelle Lager Beer. Kleine Deutschland (little Germany) was just one of his international habitats. Although the German beer gardens were a permanent crowd pleaser, other cultures were introduced on a seasonal basis. One could determine Starin's theme of the year by the souvenir curios on the mantles of Westchester homes.

Starin's Glen Island Resort began its decline in 1904. That summer, New York's worst maritime disaster claimed nearly 1,000 lives. Although those aboard the ill-fated excursion boat were headed for Locust Point on Long Island and the ship was not Starin's, the event dealt a devastating blow to the steamer-dependent resort. Glen Island declined and closed before Starin died in 1909.

Hudson's Grove, a privately owned spot for bathing and picnicking on the Long Island Sound shores, became New Rochelle's first public park when it was purchased from Alexander B. Hudson by the Town of New Rochelle in 1886. Commanding panoramic views of Echo Bay, the hub of the community's trade and recreational boating heritage since its earliest years, Hudson Park became a popular trolley destination.

Hudson Park Pavilion's special Sunday dinner menu offered fruit cocktail, choice of soup, choice of roast-stuffed Philadelphia chicken, roast leg of lamb, roast sugar-cured ham, roast prime rib of beef, new string beans, boiled or French-fried potatoes, lettuce and tomato salad with Russian dressing, assorted homemade fruit gelatin, ice cream, butterscotch pudding, tea, or coffee. The 1927 price for dinner was $1.25.

A panoramic view, pleasant entertainment, and cool breezes on a warm evening—the Hudson Park band shell offered this and more to the crowds who gathered on the hilltop, beginning in 1929. Opera, concerts, and beauty pageants were among the offerings that filled the park and summer evenings with music and vivacity. The band shell continues to entertain crowds today.

Home to competitive and prestigious oarsmen and one of the local society's hot spots, the New Rochelle Rowing Club was founded in 1880 and built its first home (above) the next year. A new building went up on the same location in 1896, where it still stands today. Club members have won scores of regional and national trophies over the years, with the height of competition in the 1920s.

Yachts, sculls, and other pleasure craft filled Echo Bay, gradually taking the place of sloops and ships carrying goods to faraway lands. The New Rochelle Rowing Club, the building on the right in this 1902 photograph, shared the shoreline with other clubhouses over the years, including the New Rochelle Yacht Club, the building on the left.

"Old" Capt. George Loyd delivered a thunderous tribute by igniting his cannon each Fourth of July. The colorful seaman was known throughout the area for his tasty pickled fish and impromptu orations. The captain settled in New Rochelle after serving in the Confederate army.

41

NEW ROCHELLE YACHT CLUB, NEW ROCHELLE, N.Y.

In a "perilous undertaking," as reported in the November 16, 1901, *New Rochelle Pioneer*, the clubhouse of the New Rochelle Yacht Club moved from the mainland to Harrison Island. It was the second time the building had truly lived up to its name, as the clubhouse had been barged from its original spot on Echo Island to the shore in 1895. Organized in 1868, the club was one of the most venerable on Long Island Sound.

EARLY VIEW OF THE PLANT FROM WHICH THE NEW ROCHELLE COAL & LUMBER COMPANY HAS DEVELOPED

Whaleboatmen skirted warships by taking cover in Ferris' Creek, an inlet from Echo Bay, during the Revolutionary War. After the war, it became a meeting place for Shube Merritt and his band of "skinners." In the mid-1800s, the waterfront access was ideal for shipping sealing wax from Thaddeus Davids's factory located on the shore. The spot became home of the sprawling New Rochelle Coal and Lumber Company, one of New Rochelle's largest business concerns. It operated from 1861 until 1945, when the property was purchased for the New Rochelle Municipal Marina.

A LATER PHOTOGRAPH INDICATING EXPANSION

The third yacht club to be established on the western part of the sound, Neptune Yacht Club was founded in 1894 on Neptune Island in New Rochelle Harbor. The organization soon changed its name to the Huguenot Yacht Club to reflect its community's founders. The original boathouse, located opposite Glen Island, burned in 1965, and the club purchased its current Spanish Mediterranean–style home. The house was the former home of actresses Lillian and Dorothy Gish, who rented it in 1919 and 1920 while they were filming at D. W. Griffith's silent movie studios in Mamaroneck. Lillian directed a film for Griffith while living here. *Remodeling Her Husband*, as the film was titled, starred her sister Dorothy and was shot in entirety in New Rochelle.

Three

SUMMER HOMES IN THE COUNTRY, PHILANTHROPY, AND NEW CITIZENS

For the upper echelon of Manhattan, New Rochelle was the perfect location for a summer home in the mid-1800s. Huge tracts of farmland on prime waterfront property could be bought up easily and inexpensively. Big and impressive homes were ready to be designed, built, and constructed by the best contractors and architects. A moneyed social scene began to flourish.

Davenport Neck was a choice spot for these large new homes and their picturesque gardens. The Davenport family, for whom the important promontory was named, commissioned one of the country's leading architects, Alexander Jackson Davis, to design Overlook (now Wildcliff) above Echo Bay and the larger Gothic villa Sans Souci in the middle of Davenport Neck. Other Davis-designed houses were built inland for Col. Richard Lathers.

International banker Adrian Iselin Sr. and his seven children eventually transformed other farms on Davenport Neck into extraordinary estates. Their first summer home went up in 1858. Over the next 60 years, the Iselins not only lived and played well in their country estates, but they also gave generously to their adopted community. Parks, houses of worship, schools, the hospital, and even New Rochelle's water system were funded by the members of the philanthropic family.

The construction and maintenance of the many grand homes being built in New Rochelle translated into jobs for immigrants coming to America. The growing community was the first stop on the New Haven rail line. By 1900, New Rochelle's population had topped 14,700. Nearly a third of the residents were foreign born.

The top of Franklin Avenue provided a bird's-eye view of Davenport Neck, as seen in the early 1880s photograph above. Farmhouses and homes of New Rochelle's working class shared the neck with the estates of the Davenports, Iselins, Phelpses, Lawtons, and Thornes.

Columbus Iselin, the third son of financier and philanthropist Adrian Iselin Sr., built his home Maison Bleu at the entrance to Davenport Neck from Hudson Park Road. Columbus Iselin made his fortunes in textiles and eventually owned over 50 tracts of land in New Rochelle, Pelham, and Eastchester. He also developed New Rochelle's neighborhood known as Sycamore Park.

Col. Delancey Astor Kane and his wife, Eleanor Iselin, had a panoramic view of Long Island Sound and Fort Slocum on Davids' Island (above) from their Davenport home, the Paddocks (below). It was a fitting name for Kane, whose interest in horses led him to popularize coaching in America. His Tally-Ho stagecoach was the first private stagecoach for pleasure riding. Kane was the great-grandson of John Jacob Astor and inherited an estimated $10 million. Eleanor, the first daughter of Adrian Iselin Sr., brought to their marriage considerable funds as well. The home later became the Colony Club, which was torn down in the 1980s.

THE N. Y. AND NEW ROCHELLE COACH
TALLY-HO

leaves the Hotel Brunswick, New York, daily (Sundays excepted), at 10 A. M. for the Castle Inn, at New Rochelle, arriving there at 12 M., and leaves New Rochelle (Castle Inn) at 3.30 P. M., arriving in New York, (Hotel Brunswick), at 5.30 P. M.

TIME TABLE and FARES.

Fares.	LEAVING New York ARRIVE AT	Time.	Fares.	LEAVING New Rochelle ARRIVE AT	Time.
	New York	10.		New Rochelle	3.30
50 cts.	Harlem	10.30	25 cts.	Neptune House Cor.	3.38
"	Mott Haven	10.37	"	Pelham [Bolton Priory.]	3.45
75 cts.	Fox's Corner	10.58	"	Bartow [Bartow Hotel.]	3.55
$1.00	Union Port	11.09	50 cts.	Pelham Bridge [Fowler's Hotel.]	4.
"	Westchester [Rood's Hotel.]	11.15	75 cts.	Westchester [Rood's Hotel.]	4.15
$1.50	Pelham Bridge [Fowler's Hotel.]	11.30	"	Union Port [Swan Inn.]	4.18
"	Bartow [Bartow Hotel.]	11.36	$1.00	Fox's Corner	4.35
$1.75	Pelham [Bolton Priory.]	11.45	$1.25	Mott Haven	4.53
"	Neptune House Cor.	11.52	$1.50	Harlem	5.
$2.00	New Rochelle	12.	$2.00	New York	5.30

FARE, $2 EACH WAY. BOX SEAT, 50 CTS. EXTRA.

Passengers' luggage up to 45 lbs. free. Parcels taken at moderate rates and punctually delivered. Places may be secured at office Hotel Brunswick, N. Y., and Castle Inn, New Rochelle.

N. B.—Passengers cautioned to be on time.

With yellow panels and running boards, a dark top, and seats on the roof for passengers, the Tally-Ho stagecoach was easily identifiable as it made its excursion trips from the Hotel Brunswick in Manhattan to the country each summer day in the late 1800s. Over the years, the Huguenot Hotel, the Queen City Hunt's Club (the former Castleview), and the Neptune House each served as the terminus for the unique pleasure trips offered on the luxury stagecoach. Many of the fashionable passengers ended their trips with a social call to the Paddocks, the Davenport Neck home of the owner of the stagecoach, Col. Delancey Astor Kane. (Karen S. Allen.)

48

Adrian Iselin Sr.'s second son, William E. Iselin, who took over his father's lucrative dry goods business, built the Anchorage as a summer home for his wife, Alice Jane, and family. Like his siblings, he was a superb yachtsman and was able to moor his prizewinning craft off the shoreline of his property. His home later became the Davenport Club. Although altered over the years, the building remains as the last Iselin home still standing in New Rochelle.

Of all the Iselin children, C. Oliver Iselin was the most famous. He was the four-time defender of the America's Cup. He built a breakwater in New Rochelle's Echo Bay so that he could safely harbor the *Vigilant, Defender, Columbia,* and his other yachts close to home. His imposing brick mansion still overlooks the bay from the tip of Premium Point in the town of Mamaroneck.

Most likely built as a wedding gift for Cyrus Lawton and his wife, Sarah Marie Davenport, Overlook was designed by one of the top architects of the day. Alexander Jackson Davis was noted for connecting his residential works with the landscape, giving them a variety of textures and appeal. Wildcliff, as the Gothic cottage was later renamed, was gifted to the City of New Rochelle by the Julius Prince family. It was listed on the National Register of Historical Places in 2002. (Alice and Anne Megaro.)

Sans Souci, Newberry Davenport's grand mansion at 157 Davenport Avenue, was also designed by Davis. A Gothic villa that included gardens and lawns sweeping to Long Island Sound, the estate epitomized those of the picturesque design popular during the Romantic period. In 1859, six years after it was completed, Anna B. Evans became the next of many owners. The house was listed on the National Register of Historic Places in 1980.

After spending many summers in New Rochelle, Col. Richard Lathers bought a large farm and commissioned Davis to build his country home. Completed in 1848, the large Italianate villa was named Winyah after Lathers's southern home. Lathers had Davis design other houses on his extensive acreage, including homes purchased by artist Frederic Remington and playwright Augustus Thomas. Winyah was destroyed by fire in 1897.

John Stephenson, inventor of the horse-drawn streetcar, was a frequent vacationer to New Rochelle. He and his wife purchased a large tract of shoreline property in 1862 and constructed a year-round residence. Clifford, as the towering mansion was called, took seven years to complete. It had a commanding view of Echo Bay and the then-stagnant Crystal Lake, which Stephenson eventually purchased and filled in to squelch a malaria scare. In 1918, the former Stephenson estate was purchased by the Salesians of Don Bosco. Clifford now serves as the headquarters of the Salesian Order's Eastern Province.

An active crusader for the temperance movement and a trustee of the New Rochelle public schools, John Stephenson (left) was also a devout and conscientious member of St. John's Methodist Episcopal Church. When the congregation outgrew its 1844 building on Bank Street, he gave generously for the construction of a suitably sized St. John's Methodist Episcopal Church on Main Street and LeCount Place. Referred to as the "green church" due to the color of its Pennsylvania stone, the impressive Romanesque Revival structure rose on the old LeCount homestead and was completed on May 31, 1901. The congregation later merged with the Methodist church in Wykagyl, where its cemetery was reinterred. The building was torn down in the 1960s and replaced by the New Rochelle Mall.

Thaddeus Davids built a handsome home (pictured) near his sealing wax factory by Echo Bay. In 1856, he purchased New Rochelle's largest island with the intention of building an ink-manufacturing plant. Although the factory never materialized, Davids' Island became a popular steamboat destination, sometimes seeing up to 5,000 visitors picnicking on the meadows formerly used for cattle grazing. Many of Davids's 12 children became prominent members of the community. Thaddeus himself was a supervisor, village trustee, and member of the board of education. His estate was purchased by George William Sutton III, who developed the neighborhood of Sutton Manor.

The owner of the Metropolitan Hotel in New York, Simeon Leland, bought 40 acres of farmland overlooking Long Island Sound for his country retreat. Builder-architect Thomas Beers took four years to complete the Gothic Revival Castleview, which included a moat and fine woodwork crafted by masters brought over from Germany. Leland soon had an important role in New Rochelle real estate. He rented and then purchased Davids' Island, then rented and sold it to the federal government during the Civil War, all at a healthy profit. However, he died penniless, a victim of Tammany Hall. The property served various functions before it was sold to Adrian Iselin Jr., who conveyed it to Mother Irene Gill, prioress of St. Theresa's Convent in New York. By 1904, Gill had established the College of St. Angela, the first Catholic women's college in New York State. The name was changed to College of New Rochelle in 1910. Leland Castle was listed on the National Register of Historic Places in 1976.

As the tide of immigration crested following the 1848 uprisings in Germany, so did the availability of workers for the brewery that George Schaefer operated on Union Avenue. The western part of town became known as Dutch Hill, an anglicization of Deutsche, and included the Brewery Hotel and Park. By 1875, the brewery for New Rochelle Lager Beer was the eighth largest in the state.

Once the brewery closed in the 1890s, the Germans slowly moved out of Dutch Hill, and another immigrant group, predominately Italian, made the west of New Rochelle its home. Leaving their homeland for jobs building schools, railroads, and neighborhoods in the early 1900s, the men eventually brought their families from Italy, establishing their own little Italy. This photograph of the Cassara Brothers Wholesale Produce business on Union Avenue was taken in 1909.

When he retired in 1878 at the age of 60, Adrian Iselin Sr. focused his attentions on spending money on charitable endeavors. After starting the community's first savings bank and water service, he turned to construction projects. He had a stunning brick building constructed on the southeast corner of Centre Avenue and Main Street to serve as a gymnasium.

Iselin and his wife, Eleanora, a devout Catholic, donated the funds to construct St. Gabriel's Catholic Church. Intended to serve the Germans living in Dutch Hill in west New Rochelle, the church was consecrated in 1893. A few years later, the Iselins turned the gymnasium over to the church, and it became St. Gabriel's Parochial School.

As the Italian community grew in the western part of New Rochelle, so did the need for another Roman Catholic church. St. Joseph's Church was founded by Rev. Pasquale Manzelli in 1901. Parishioners flocked to the small wooden structure for the services held in Italian. By 1904, a new building had been started with funds from the Iselins. In 1912, their daughter Georgine purchased the land next to the building and funded the construction of a school and convent.

When the first Blessed Sacrament Church burned to the ground in 1890, the Iselins offered to fund a new structure. Rev. Fr. Tom McLoughlin, who served the congregation from 1853 to 1902, chose not to accept the offer. However, funds were raised for the impressive marble church that was dedicated in August 1897. It is the oldest Catholic congregation in the community, having started in 1848 as St. Matthews Church on Drake's Lane.

In 1873, several New Rochelle families observed Yom Kippur, gathering together under a tent on a lot near Main Street. The community's first synagogue, Anshe Sholom, rose on Bonnefoy Place in 1904. Adrian Iselin Sr., an Episcopalian, and his wife, Eleanora, a Catholic, contributed 10 percent of the land costs. Founders included Main Street business owners Benjamin Cohen, Jacob Wilinski, Morris Berzon, and Charles Hamburger.

In the early 1900s, a group of wealthy New Rochelle women founded the Colburn Home for the Aged, a quality and comfortable residential institution that provided for their domestic workers in their retirement years. It provided a caring home for scores of older individuals for nearly a century.

With black bags in hand, a few doctors in horse-drawn buggies made rounds throughout the community to treat the sick. Those who were seriously injured and requiring a hospital had to be transported to the depot where they waited for the next train to New York or New Haven. Seeing a critical need for his town, William Rafford Pitt rallied the support of ministers, doctors, and wealthy friends to raise money and supplies for a hospital. Although patients were seen in a small house purchased on Huguenot Street in 1892 (above), the yellow home was outgrown within a year. A larger one was bought, and the New Rochelle Hospital continued to grow at its current location on Guion Place.

The growing community held attractive promises for good jobs, including construction and domestic work for the wealthy in the large estates and for the new middle class that was quickly being establishing. In the late 1800s, when this photograph was taken, an area of town became a makeshift community of tents and wagons, with people looking for employment. Located near Petersville Road, it was called Jerusalem Lane.

Four

Residential Parks Just 45 Minutes from Broadway

New Rochelle on the Sound, first published in 1903 by local photographer John Rosch, touted the many virtues of purchasing a home in New Rochelle.

> The almost entire absence of manufacturing interests and the many private parks (for residence) of great natural beauty, including Rochelle Park, Residence Park, Huguenot Park, Neptune, Home and Homestead Parks, Sycamore, Halcyon and Columbus Parks, together with the vast tract of Beechmont, testify to the varied charm and adaptability for healthful, attractive, convenient, and artistic home sites. To the lover of salt water and its sports, such as sailing, rowing, fishing, and swimming, the public parks, so picturesquely situated on the waterfront, gives those whose homes are situated away from the shore almost if not quite an equal advantage with the residents occupying and owning superb villas directly on the sound.

Beginning with Rochelle Park in the 1880s, residential parks, as these planned neighborhoods were called, rose on cleared meadows and lawns. Development groups, usually comprised of a few local lawyers, bankers, and investors, bought up former farms and estates, hired landscape designers to lay out attractive roadways and open space, and divided up the lots in sizes according to the clientele they sought to attract. These early suburban neighborhoods were hugely popular, particularly with the brand-new breed of American worker: the commuter.

Although George M. Cohan's smash hit musical *45 Minutes from Broadway* poked fun at the rubes (country folk) in New Rochelle, the community was rapidly becoming one of the most fashionable in the New York area. In 1906, when the show opened on Broadway, the local newspaper's society page was a virtual who's who of prominent artists, actors, and businessmen.

During this period of growth, two local industries also flourished: The silent movie studios of the Thanhouser Film Corporation and the acres of greenhouses growing exotic plants at Rose Hill Nurseries added considerably to New Rochelle's national notoriety.

When George M. Cohan hopped the train to visit his friends "hoofer" T. Harold Forbes and vaudevillian Eddie Foy, the sight of the train station inspired him to write his hit 1906 musical *45 Minutes from Broadway*. Although the musical made fun of the country atmosphere of New Rochelle, the short train trip from Manhattan was actually responsible for the community's rapid rise. This 1908 photograph was snapped as the Excelsior Band was passing through town. The building is still used for its original purpose.

This late-1800s photograph of the Highland Park neighborhood, above the Mahlstedt family's ice lakes at North Avenue and Eastchester Road, shows rural meadows awaiting development. Maps from 1901 display sections of farmland crisscrossed by lines representing streets. Identified by British-sounding names such as Aberfyoyle, Calton, Inverness, and Perth, the new roads are lined with tidy lots, some of which contain a house and new owner's name.

Rochelle Park was the first residential park to be laid out in New Rochelle and among the earliest planned neighborhoods in America. Its plans were filed in the Westchester County Clerk's Office in 1886. Landscape architect Nathan Barrett used a bold new concept, designing the 75 acres in an asymmetrical plan with open, common spaces and interesting views. The Colonial homes in the photographs were among the first to be built. Today Rochelle Park and its adjacent neighborhood, Rochelle Heights, comprise a locally designated historic district that was also listed on the National Register of Historic Places in 2005.

A number of prominent artists were among the well heeled who built Rochelle Park's first homes. Artist Ernest Albert, whose house became the home of the Elks Club, lived across the street from illustrator Orson Lowell.

The neighborhood was bordered with beautifully designed stone walls that, according to the *New York Daily Paragraph*, "gave the area more of the idea of a large private estate than a public park." It was originally a gated community with a hired police officer on duty full-time, and the residents invited the general public for a picnic on the Lawn once a year.

Liberty Avenue and Elm Street, New Rochelle, N. Y.

Adrian Iselin Jr. acquired the former 40-acre Leland estate and Castleview in 1884 and then purchased 60 adjacent acres. With a hillside overlooking the nearby Long Island Sound and tree-lined streets curving around small greens, he created the highly desirable Residence Park. By 1888, the new grand neighborhood that extended from Main Street to Pelham Road and from Woodland Avenue to Centre Avenue had 66 homes, nearly all of which were "elegant Queen Anne cottages," as reported by the *New Rochelle Pioneer*. Within decades, it became home to a number of notables, including tennis great Francis T. Hunter, cartoon artist F. Burr Opper, playwright Robert Anderson, and baseball great Lou Gehrig and his parents. (Above, Karen S. Allen.)

On the seven acres of the former Thaddeus Davids estate, George William Sutton III laid out the neighborhood of Sutton Manor in 1904, seen in the photograph above from across the bay near the entrance to Hudson Park. Sutton had no trouble selling the 45 building lots in the enclave that was ideally situated within walking distance to the train—and on a sheltered bay. It was a perfect neighborhood for the commuting businessmen who were as passionate about sailing as they were about making a good living. The Sutton Manor home below was described as being "Early English Country architecture" in a 1909 booklet.

To create the upscale residential park of Beechmont, City Realty was formed in 1901 by the Lambdens, prominent community members. They purchased the former Montgomery and Pugsley farms that began at North Avenue and extended toward the town of Mamaroneck border. As the neighborhood's centerpiece, they damned Pine Brook to create Beechmont Lake. The first of many fine homes were sold in 1904.

Entrance to Halcyon Park from North Avenue, New Rochelle, N. Y.

Halcyon Park grew on the area known as Brookside, the former home of Dr. Hubert and Annie Foote, whose daughter Irene married Vernon Castle. Part of the residential park's property had been previously used as a silver mine, a quarry, and Frank J. Holler's ice business. The neighborhood is now adjacent to Iona College, which began in 1940. (Karen S. Allen.)

Glamorous couple Irene and Vernon Castle captivated the hearts of dance-crazy America with their innovative steps, grace, good looks, and charm. The internationally renowned dance team's tragically abbreviated life together began during the summer of 1910 at the New Rochelle Rowing Club, where young New Rochelle native Irene Foote met her first husband-to-be. Vernon was killed in a plane crash during World War I.

The "funniest man in the world," as vaudeville star Eddie Foy was called by the press in the late 1800s, settled his family in a large house on Weyman Avenue called the Foyer. When they were not touring the great vaudeville houses across the country or performing at a local charity event, Eddie Foy and the Seven Little Foys frequented Hudson Park, where they were captured in this photograph in the early 1900s.

From 1891 to 1908, artist Frederic Remington and his wife Eva lived on their Webster Avenue estate, Endion, pictured above with Remington and his horse. He traveled to the West, photographed Native Americans, cowboys, and landscapes, and returned to his New Rochelle Endion studio (right) to create his world-famous paintings and sculptures. Their home was designed by architect Alexander Jackson Davis for Col. Richard Lathers. Remington, Edward Kemble, and Rufus Zogbaum were among the first of numerous famed artists in the community. (Frederic Remington Art Museum.)

Joseph C. Leyendecker and his younger brother Francis came to America from Germany with their parents. Both illustrators, the older Leyendecker sold his first cover to the *Saturday Evening Post* in 1899. By 1914, his success allowed him to build a palatial home with fabulous gardens on Mount Tom Road. Pictured in this 1920s photograph is Francis Leyendecker working in his studio in his own wing of the house.

Norman Rockwell wrote about his early days in New Rochelle: "I was surrounded by success. Men of affairs, commuters lodged at Edgewood Hall. Downtown I often saw Coles Phillips, the celebrated pretty-girl artist, or Clare Briggs, the well-known cartoonist. Almost everyday on my way to work I'd pass J. C. Leyendecker, the famous *Saturday Evening Post* illustrator, walking to the railroad station to catch a train for New York."

Rockwell's parents moved to Brown Lodge (above), which stood at 39 Prospect Street. When he was 17 years old and had just illustrated his first children's book, Rockwell quickly made his way into the flourishing artists' colony that had taken root here. By 1916, when he was 21, Rockwell sold his first cover to the *Saturday Evening Post*. The same year, he rented George Lischke's barn (below) at 40 Prospect Street for his studio, one of many during his 25 years in New Rochelle.

In 1905, members of the Pelham Country Club acquired 175 acres of land along North Avenue and Quaker Ridge Road from the Disbrow family, who had farmed the land for about 50 years. Club member Lawrence Van Etten fashioned the first 18-hole golf course. Within three years, the Wykagyl Country Club had an astonishing membership of 450 members. Since then, it has hosted some of the country's leading tournaments and players.

An avid golfer, Clare Briggs built his stunning English Tudor home just off the golf course of the Wykagyl Country Club, which he joined in 1914. Fashioned from salvaged timbers from an 18th-century schooner, the house was built to blend with the landscape. The house is still a private residence in a woodland garden setting.

At the height of his career, Briggs's cartoons appeared in 180 newspapers, read by two million people. The Wisconsin native was best known for *When a Feller Needs a Friend*, *Someone's Always Taking the Joy Out of Life*, *The Days of Real Sport*, and *Golf*. He posed for the *New Rochelle Tattler* (right) and inked the cartoon below for the publication. At some point, he began signing his name "Briggs, Wykagyl," which helped bring national fame to his beloved country club.

Drawn for The Tattler by Briggs.

At its height of popularity between 1912 and 1917, the Thanhouser Film Corporation produced up to three silent movies a week to be shown in theaters across America. In addition to its 140 employees, the company used many locals as extras and New Rochelle buildings and neighborhoods as movie sets, including the first high school (now city hall).

From coast to coast, thousands of Americans viewed the hundreds of popular silent films produced in Edwin Thanhouser's New Rochelle studios, built in 1909 at Centre Avenue and Grove Street. After a dramatic and leveling fire on January 13, 1913, the company quickly relocated to Main Street near Echo Avenue, where its waterfront property developed into one of the largest filmmaking complexes in the country.

Newly built row houses along Stephenson Boulevard were sold by a real estate office, as seen in this photograph taken in 1910. Among the first attached houses in New Rochelle, the homes were constructed on the former John Stephenson estate. When the Thanhouser Film Corporation moved its silent movie studios to Main Street in 1913, several of the employees lived in these new Stephenson Park houses.

German-born Henry A. Siebrecht created one of the country's largest nurseries by buying up 90 acres of New Rochelle's fertile land. Rose Hill Nurseries, with its entrance pictured here, extended from North Street (North Avenue) to the Hutchinson River. About 68 enormous hothouses were filled with winter-blooming lilies of the valley, orchids, roses, and other flowers never before seen in the Americas. The nursery furnished elite florists in Manhattan and premier estate gardens.

Although this 1890 photograph of the Scarsdale Land Improvement Company on Wilmot Road in New Rochelle suggests that development of the community's upper reaches was prominent, it was not. Northern New Rochelle remained primarily farmland for several more decades, with the major growth occurring in the 1920s and after World War II.

In this photograph from the late 1800s, a dapper group of gentlemen is posing on the ice of Titus Mill Pond. At the end of New Rochelle's lower harbor, the pond formerly housed the Lispenard Mill that was powered by tides spilling over a dam. Pelham Road is above the hill.

Five

Hometown America Becomes a 20th-Century City

Just before the dawn of the 20th century in April 1899, New Rochelle was incorporated as a city. The village and town became one entity, with a newly structured form of government. The city was divided into four wards, with an elected mayor and 14 aldermen as the governing body. On April 18, 1899, Michael J. Dillon, a Democrat, defeated Hugh A. Harmer, a Republican, to become the first mayor of New Rochelle. He won by a slim margin of 22 votes that were cast by men only. Women did not have the right to vote for another 21 years.

New Rochelle's population was mushrooming. The community's expansion of public buildings, neighborhoods, schools, Main Street businesses, houses of worship, and civic pride kept pace. Sewer lines were installed, the water company expanded to include an additional reservoir, and a new lighting company formed so that lights were available in the daytime as well as at night. Trolleys were still a key mode of transportation, and by 1900, they were electrified. Bicycle shop owner Adolph Lasus had one of the first automobiles in the city, buying a Waltham buckboard in 1902.

A second park was opened to the public, thanks to Adrian Iselin Jr., who bought the old Neptune House property and gifted the three and a half acres to the city in 1901. Just below Neptune Park, ferries left the dock carrying army personnel, building materials, and goods for Fort Slocum. The post on Davids' Island, part of the New York Harbor Defense System, was continuing to be built up with permanent structures.

In 1909, a big parade celebrated New Rochelle's 10th anniversary as a city. Three years later, an even bigger event marked the 225th anniversary of the founding of the "Queen City of the Sound," as New Rochelle was now referred. The 1913 celebration was a perfect time to reestablish ties between the French city for which it was named. The mayor of La Rochelle was on hand for the festivities, including a historically inaccurate reenactment of the Huguenots sailing into Echo Bay (the earliest settlers came by horse-drawn wagons from Manhattan), parades along a festooned street, dedications of memorials, and other spirited activities. The residents were clearly proud of their long and unique heritage.

New Rochelle Town Hall became New Rochelle City Hall in 1899. The building served the community at its Main Street and Mechanic Street (Memorial Highway) location from 1847 to 1960, when city hall moved to 515 North Avenue. Although the brick structure was razed soon after, its cupola continues as a reminder, perched on the New Rochelle Rowing Club. This 1920s photograph includes the liberty pole that could be seen for miles.

When New Rochelle became a city, the police officers became responsible for New Rochelle's full 6,000 acres, not just the village. By 1912, the department had outgrown its space in city hall on Main Street and moved into the first dedicated police headquarters nearby on Lawton Street. The first patrol car, a used Cadillac, was purchased the same year.

The impressive three-story gray stone structure included the New Rochelle City Court and Westchester County Clerk's Office on the second floor. Police quarters on the first floor included 10 cells for male prisoners and 2 for women. In the 1960s, when police headquarters moved to an annex of city hall at 515 North Avenue, the building was torn down for Library Plaza and is now the Lawton Street parking lot.

Bicycle patrols to protect downtown and the summer crowds in Hudson Park were key to the police department until the motorcycles and patrol cars made them obsolete by 1925. Those watching the parade photographed in the 1920s assumed they were watching the last uniformed police on bicycles.

Within a stone's thrown from New Rochelle City Hall, a fire headquarters building (above) opened on Church Street in May 1901. Following a string of devastating fires to New Rochelle businesses, the city fathers continued measures to improve the patchwork fire service comprised of six fire companies run by about 300 volunteers. First, they created a paid position to lead the service. Former volunteer firefighter James Ross was appointed fire chief, a position he remained in until his death in 1919.

When left unattended on a winter night in 1910, the Olympia Engine Company's firehouse caught on fire and was destroyed. The City of New Rochelle constructed a new building on the same site on North Avenue near Eastchester Road. Completed in 1912, it included two company rooms, dormitories for the professional firefighters, and a locker room. Station No. 3, as it is now referred to, retains its original appearance except for wider bays that were needed to accommodate larger and motorized apparatus.

In addition to their Davenport Neck holdings, the Iselins owned extensive farmland in the northern part of New Rochelle. In 1901, Adrian Iselin Jr. provided funds to build the Wilmot Fire Station at the southwest corner of Wilmot Road, North Avenue, and Mill Road. Now a private residence, the Wilmot Fire Station was replaced by station No. 5, which was built at the end of Pinebrook Boulevard in 1950.

The imposing design of this building was a clear statement of the organization that raised the money for its construction. The Fraternal Order of Masons located its headquarters in the heart of the early business district and hired prominent architect George T. Thompson to design the classical and monumental building on Main Street and LeCount Place in 1901.

Soon after the Masonic building was completed, the library moved from its temporary quarters at 40 Centre Avenue to the upper two floors of the new Main Street building. The library had been leasing space in the first New Rochelle Trust Company after outgrowing its first home on the third floor of Trinity Place School where it began in 1893. It received its charter from the University of the State of New York in 1894.

The Masonic hall location served the library well for nearly 10 years. In addition to the general library space and shelves stocked with books for borrowing, the leased floors allowed for a large reading room, a reference room, and a designated children's room (above).

After outgrowing its quarters in the Masonic building, the library moved into its own new home at Main Street and Pintard Avenue in 1914. The handsome Beaux-Arts-styled structure was funded by Andrew Carnegie as part of his program to further American libraries, with matching city funds of $50,000. Among the first young patrons were Joseph Campbell, who became a leading writer and mythologist, and Elia Kazan, whose plays and movies are now classics.

A momentous neoclassical structure was constructed for the first high school building, which was completed on North Avenue in 1906. Previously, students above the eighth grade were housed in the Trinity Place School and then in rooms rented above a meat market and recreation hall in Pershing Square. Within 10 years, additions were required to the seemingly spacious facility, and an entirely new building was needed by the 1920s. One of the early graduates was Anna Bernard Jones, who became a teacher and an attorney. She was the first African American woman to be admitted to the New York State Bar Association. Today this building is New Rochelle City Hall.

Starting a string of school construction to accommodate an ever-growing population, the third public elementary school was built on Winyah (Lincoln) Avenue in 1898. Trinity Place School (1884) and Union School (1889) preceded the Winyah School building (pictured), and it was later replaced by Lincoln School, which was torn down following the landmark desegregation case in the 1960s.

As children filled the homes in the newly developed residential parks, including Halcyon, Huguenot, Highland, Beechmont, Forest Heights, and other neighborhoods, New Rochelle's fourth school was built and named for its street off North Avenue. Mayflower School was completed in 1910. Today it is owned by Iona College. The year before, a school was built to accommodate the newcomers in west New Rochelle, particularly immigrants from Italy. It was named after Christopher Columbus.

On a hillside above acres that had been Crystal Lake, Stephenson School was completed in 1913, the last of the school expansion before World War I diverted attention, building goods, and labor. The school was an easy walk for children in the new neighborhoods of Stephenson, Hazlehurst, Home, Homestead, Sun Haven, Stonelea, and Premium Point Parks. After redistricting in the 1980s, Stephenson School was razed and replaced by a recreational park.

From the 1700s, when Rev. Pierre Stouppe conducted classes at Trinity Church for young men, including John Jay, the first Supreme Court chief justice, a number of private schools operated in town. By the late 1800s, they were providing an alternative to public school. New Rochelle School and Kindergarten, pictured in this 1919 photograph, was located at 200 Centre Avenue.

In a photograph looking down Main Street from just above Centre Avenue, George Ferguson's store dominates the northern corner on the right. Scott's Hay and Grain is on the left. If this 1905 photograph had been taken anytime after 1928, the passenger of the horse-drawn carriage would most likely be visiting Talner's Jewelers, which has occupied the spot since then.

Ferguson's bicycle shop, in the larger Ferguson's store on Main Street and Centre Avenue, was one of several bicycle stores keeping up with cycling's great popularity. This 1900 photograph shows that the new low safety bicycles had taken the place of the old high-wheeled ones.

The four-story New Rochelle Trust Company, bannered for a 1909 celebration in the photograph, began as the two-story Bank of New Rochelle, the community's earliest financial institution, founded in 1888 by local notables Alexander B. Hudson, George Ferguson, George T. Davis, and Edward Lambden. The Romanesque Revival structure was designed by Carlos Merry in 1894 and topped off with two stories in 1908. Offices are now located throughout the 542 Main Street building.

In 1897, the arcade building, pictured on the far right of this 1900 photograph, opened on Main Street with great publicity. Called the "best gymnasium in the country," William Weisskopf's beautifully appointed place included meeting, game, and hotel rooms, several eateries, and shops. Bowling alleys were in the basement, and the rooftop garden encouraged dancing. The first New Rochelle YMCA leased space in the arcade, which became the home of the Curtain Shop in 1993.

Traveling east on Main Street, the first building past Church Street was one of the first brick edifices in downtown, having been constructed in 1886. Looking very much the same today, it has been Liebman's Clothing Store since 1927. Pictured about 1895, the next store was Bon Ton Fish Market and then Hoffmeister Market, which offered all goods for the discerning household.

90

The employees of Swift and Company are proudly posing for a company photograph, complete with the horses that pulled the delivery wagons, in 1908. The purveyors of choice meats were located at 137 Huguenot Street.

Men could pick up the latest news and get a haircut and shave "for two bits" at the Breuckne Barber Shop, which was located at 30 Mechanic Street. In the 1960s, the street was widened for Memorial Highway, and the building housing the shop was torn down.

The eclectic exterior of the Rosch and Kopff building at 301 North Avenue set the tone for the lavish photography studios inside. Here families would sit for portraits with backdrops and props fit for royalty. Owner and photographer John Rosch published *New Rochelle on the Sound* in 1903, using his images to promote the beauty and amenities of his community. Postcards from the time period often bear his signature.

92

The architect who designed the Lincoln Memorial in Washington, D.C., also rendered the drawings for the first bank building in New Rochelle at the corner of Main Street and Lawton Avenue. Henry Bacon completed the plans for the impressive First National City Bank in 1901, soon after he left the firm of McKim, Mead, and White. Within just a few years, it needed to be enlarged with an addition.

Clark Davis began a funeral business in Upper New Rochelle in 1864. His son George Tolliver Davis, a Civil War veteran who became active in every aspect of the growing community, took over the business in 1871 and moved it to downtown New Rochelle. For decades, it was located at the corner of Huguenot and Rose Streets, pictured in this 1891 photograph. Rose Street eventually became part of North Avenue.

The delivery wagon of Kusche's Market was a familiar sight in New Rochelle in the late 1800s and early 1900s. In this 1901 photograph, a home on Premium Point is receiving goods to restock its pantry and icebox.

Milk had to be delivered, despite snow, as seen in this late-1800s photograph. The Willow Brook Dairy wagon was equipped with its own kind of snow tires and runners. The children in Residence Park hitched a ride on their sleds and prepared for a fast run down Laurel Avenue.

Washington Irving's publisher, G. P. Putnam, built his firm's manufacturing plant on Webster Avenue near Main Street in 1890. Irving's best-selling book *Deidrich Knickerbocker's History of New York* was clearly an inspiration for the massive stepped-roof, Dutch-style Knickerbocker building. For 40 years, the works of Irving, Herman Melville, Charles Dickens, and other celebrated authors published by G. P. Putnam Sons were printed and bound at the New Rochelle factory. The Knickerbocker building, a residential complex, was listed on the National Register of Historic Places in 2000.

In 1905, Benjamin Stearns was joined by a handful of other members of Anshe Sholom Synagogue in forming a new congregation practicing Reformed Judaism. The first services were held in Lambden Hall, still standing at Main and Division Streets. On June 22, 1908, the men incorporated as Temple Israel of New Rochelle and purchased the Trinity Lutheran Church at 36 Bank (now Division) Street for their house of worship.

The Salem Baptist congregation, organized in 1849, hired architect Arthur Bates Jennings to construct this 1904 church building of Tuckahoe marble. After the primarily white congregation dwindled in numbers, it was sold in 1972 to one of the city's earliest African American religious organizations, Union Baptist Church. The congregation continues to worship in the same building, although the steeple was lost decades ago.

With blessings of the First Presbyterian Church, 30 of its members built a small chapel at the threshold of New Rochelle's northern reaches. By 1907, a new stone structure with 800 seats was dedicated. The North Avenue Presbyterian Church congregation grew to nearly 1,500 by the 1930s. Four decades later, finances and dwindling numbers forced it to be sold to its neighbor and current owner, the City of New Rochelle.

With three Catholic churches in the southern part of New Rochelle, the archdiocese recognized the need for one to serve the neighborhoods pushing north. Fr. Andrew Roche held the first services of Holy Family Church in a converted butcher store on Horton Avenue. By 1917, on land donated by millionaire John Trenor, the church was completed and dedicated. The Mayflower Avenue parish underwent numerous additions in the following decades.

In 1909, Thomas Paine's cottage was moved down the hill to a plot of land donated by Simeon Lester and was dedicated as a house museum by the Thomas Paine National Historical Association the next year, along with the Sophia Brewster Schoolhouse. Over the years, other historic relics were added and the property altered, but tributes to the forward-thinking pamphleteer, such as the one pictured from 1912, have continued to attract his dedicated admirers. The Thomas Paine Cottage is now on North Avenue and is operated by the Huguenot and New Rochelle Historical Association. It was listed on the National Register of Historic Places in 1972.

New Rochelle's 225th anniversary included the June 25, 1913, dedication of the striking statue of Jacob Leisler. The Daughters of the Revolution (different from the DAR) commissioned preeminent sculptor Solon Borglum (brother of Mount Rushmore's artist) to cast the bronze memorial. Leisler served as the purchasing agent for the 6,000 acres of land the Huguenots named New Rochelle. He met a terrible fate, having assumed the title of lieutenant governor of the province of New York under King James II, for which he was convicted of felony and treason and executed in 1691. Four years later, parliament reversed the conviction.

George Washington passed through New Rochelle along the Boston Post Road several times while serving as general during the Revolutionary War and as president of the United States, documenting all his travels in diaries. In 1909, the Huguenot Chapter of the DAR memorialized his journeys by dedicating a plaque on a handsome stone monument at the tip of Faneuil Park at the east junction of Main and Huguenot Streets.

Although the Huguenots never landed on the shores of their new land, the long-perpetuated myth made for a crowd-pleasing extravaganza for the 225th anniversary. A water pageant with the replica of the *Half Moon* serving as the supposed Huguenot ship was followed by a water carnival, a band concert, and fireworks that attracted tens of thousands of spectators to Hudson Park.

Six

FORT SLOCUM AND NEW ROCHELLE'S WORLD WAR I YEARS

During the Civil War, nearly 5,000 men were ferried out to Davids' Island to be treated at DeCamp Hospital. It closed shortly after Gen. Robert E. Lee's surrender in 1865. Two years later, Simeon Leland sold the island to the federal government for $36,500. The New York State legislature ceded control of the island to the federal government for military purposes the next year. New Rochelle's largest offshore island then served a variety of military functions until the mid-1960s, seeing its greatest use during World War I. Its ties to New Rochelle were also significant during these years, as the following chapter will relate.

Immediately after diplomatic relations between the United States and Germany were severed, on February 3, 1917, a group of leading citizens organized the Citizens' Protective Committee of New Rochelle. Like communities across the country, every New Rochelle man, woman, and child joined together to do their parts. Resident and noted publisher Condé B. Pallen later edited books that documented New Rochelle's "unvarnished tale of patriotism, service, and sacrifice" during the years of World War I. Like other Americans, New Rochelle "rose to the emergency with a splendid enthusiasm and flung every ounce of their vast energy, moral and physical, into the scales with single purpose of winning the war," Pallen wrote.

But New Rochelle's wartime efforts were unusual for a community its size. With one of the country's largest recruiting depots located just off the city's shore on Fort Slocum and a naval camp nearby in Pelham Bay, New Rochelle was a destination for tens of thousands of young men on the road to war. The temporary population spiked soon after the Selective Service Act instituted the country's first enforced draft in the summer of 1917. By December, when the Department of War issued regulations that cut off voluntary enlistment on December 20, New Rochelle was pressed into unprecedented service. During the frigid week of December 10–17, 1917, the people of New Rochelle successfully housed, fed, and entertained close to 8,000 stranded recruits.

Once the drama of redemptive "recruit week" subsided, New Rochelle continued tending to the needs of young men on their way to war. In total, about 140,000 men passed through New Rochelle and Fort Slocum in a two-year period from 1917 to 1919, making it the busiest recruiting depot east of the Mississippi River.

The post–Civil War artillery and recruiting post on Davids' Island was officially named Fort Slocum on July 1, 1896, by directive of Pres. Grover Cleveland. The naming was in honor of Maj. Gen. Henry Warner Slocum, a Civil War hero who died two years prior. His portrait was featured on a postcard that was available for purchase at the fort's post exchange.

Maj. Gen. H.W. Slocum
Born 1827— Died 1894
For whom this post
Was named in 1896

THE 6 INCH, NO. 921.

The men stationed on the artillery post were on constant lookout for enemy ships that could have entered Long Island Sound from the Atlantic Ocean and head up to Hell's Gate and into the East River. In 1890, deep pits and tunnels were cut into the ledge rock, and a battery of 16 mortar cannons, one of which is pictured here, was installed on the south end of the island. Direct artillery was placed on the north end.

A large octagonal brick building was constructed as the first troop barracks in 1880. Two more identical buildings followed along with a water tower, mess hall, more buildings, and necessary infrastructure. Under the directives of the army's quartermaster, New Rochelle builders and businesses supplied the talent, labor, and goods for the rapidly growing offshore community.

On a brisk Sunday morning, November 14, 1909, the Chapel of St. Sebastian, Soldier and Martyr, was dedicated on Fort Slocum. After years of letter writing and fund-raising, Fr. Tom McLoughlin, rector of New Rochelle's Blessed Sacrament Church, realized his goal. The Spanish Mission–style house of worship was built by Peter Doern, who had also constructed Blessed Sacrament Church.

The recreational and social needs of the men at Fort Slocum were also generously considered, with a gift by philanthropist Olivia Slocum Sage to build the large and well-equipped YMCA on the post. Sage could not have possibly known the extraordinary use her bequest received in the years that followed.

When war was declared, Fort Slocum became a principal recruiting depot for the Northeast. To accommodate this vastly enlarged operation, 56 temporary buildings were constructed, along with a large mess hall, a recruit examination building, and a hospital.

COLONEL BARNETT, FORT SLOCUM, N. Y.

Most of the enlistees came by train into New Rochelle's station, where they could hop a trolley to the Fort Slocum dock below Neptune Park, the former site of the grand Neptune House. Ferries ran continuously between the dock and the island, transporting men and supplies.

In the first week of December 1918, New Rochelle was grappling with an influx of prebattle servicemen. "New Rochelle is a hell hole of vice!" headlined leading New York newspapers. After raiding saloons, marshal Thomas D. McCarthy accused owners of corrupting Fort Slocum servicemen with illegal liquor and scantily clad females within doors of town hall. Jacob Grab, owner of Germania Hall, pictured here, was one of the six proprietors arrested.

Trying to beat the December 20 cutoff of voluntary enlistment, 800 men arrived at New Rochelle's train station on December 10. In the bitter cold, they waited at the dock as the ferry continuously shuttled its capacity to Fort Slocum. By dusk, the ferry had stopped running; Fort Slocum could hold no more.

Each day that week, thousands more arrived. Each trainload was warmly greeted, and the men were marched to the headquarters that had been established at the Knights of Columbus hall. There the recruits were organized and transported to their temporary homes—churches, synagogues, firehouses, schools, private houses, the YMCA, the YMHA (Young Men's Hebrew Association), and every community hall. At Germania Hall, Jacob Grab supplied boarding, food, and continuous music.

Every New Rochellean contributed. Shopkeepers kept stores open around the clock and donated unlimited meat and groceries. Dairymen brought milk, butter, and cheese. Through the snow, residents brought money, provisions, and goodwill for the city's newly adopted sons. Under the leadership of Haganoush Kazanjian, Mrs. Bloomfield Smith, and others, the canteen ladies rolled up the sleeves of their white and blue uniforms and began a herculean cooking marathon that continued for days.

New Rochelle resident and theatrical agent Jules Delmar brought in vaudevillians to entertain. A butcher donated 200 porterhouse steaks. Other meat purveyors gave cold cuts. Dairymen came through with unlimited milk and butter. Through the snow, the city's residents brought money and provisions. The Red Cross and canteen ladies doled out free postcards and stamps, bedding, sweaters, cigarettes, and other "comfortables" to each of the city's newly adopted sons.

Outgoing Men, Fort Slocum, N. Y.

Nearly 8,000 stranded men were cared for by New Rochelle residents during the week of December 10, 1917. The citizens' efforts were heralded by appreciative letters and telegrams from the recruits' parents and mayors and in editorials in national newspapers. About 4,000 recruits signed a resolution acknowledging their appreciation of the "self-sacrifice and unselfish spirit shown by the citizens of New Rochelle" and presented it to the U.S. Congress.

With nickels and dimes, the recruits mustered up gifts of bronze plaques, silk flags, handsome watches, and holiday bouquets for their hosts. In 1919, a bronze plaque was dedicated by the Massachusetts recruits in gratitude to the citizens of New Rochelle. It can be seen today in the rotunda of city hall.

During the war, New Rochelle also raised more than its share in Liberty Loans, cultivated scores of victory gardens, and operated an extremely active and productive chapter of the Red Cross. Women drove the ambulance that was donated by C. Oliver Iselin. The famous yachtsman was most likely a member for the volunteer harbor patrol (below), diligent sentry protecting New Rochelle's waters.

The community's most painful sacrifice was that it sent over 2,500 men to fight, which was twice as many as the average for towns throughout the United States. Over 60 New Rochelle men lost their lives. The prestigious, civic-minded New Rochelle Art Association organized a fitting and lasting tribute to those men by commissioning and funding a granite memorial designed by Louis R. Metcalfe with a bronze sculpture of Victory by Edmond Thomas Quinn. The World War I Memorial was sited in the lovely setting of Faneuil Park at the east junction of Huguenot and Main Streets and dedicated on December 11, 1921.

Seven

BOOM TIME THROUGH THE 1920s

Of all eras in New Rochelle's history, the 1920s were filled with seemingly boundless opportunities and optimism. The construction that was delayed during the war years was resumed. Developers had positioned themselves for the influx of commuters wanting homes near the luxury stations of the newly opened New York, Westchester, and Boston Railway. Tudor-, Colonial Revival-, and Spanish Revival–style homes started rising on the large tracts in waiting. Among them, the former property of Gen. Daniel Sickles's family became Rochelle Heights, Col. Rudolph Otto Bergholz's estate was later named Glenwood Lakes, and the 450 acres of society dance instructor and millionaire John Trenor became Wykagyl Farms.

Population figures, both real and anticipated, put the wheels in motion for the unprecedented construction of six additional school buildings, including a very large high school. Churches and synagogues were also stretching their resources northward or considering plans to do so.

Downtown, construction vehicles shared streets with the chauffeur-driven Packards and Pierce Arrows of shoppers. The glamour and whimsy of the art deco movement dressed Main Street buildings, as owners employed the best architects and materials to attract top spenders.

Newcomers and old-timers strengthened existing community organizations and formed additional ones as needed. The New Rochelle Chamber of Commerce set the pace in 1920 when several former city-boosting entities joined into one official collective. The New Rochelle Art Association's innovative civic efforts made national press, as did many trend-setting residents.

A 1929 "City Plan and Twenty Year Program of Public Improvements" document by the planning board extolled, "We are strongly impressed with the fact that New Rochelle is at a critical point in its history.... It clearly appears to be on the eve of a new and great development. It is nearer to New York City than any other community in which there is still available a large area suitable for the development of residential districts of a high type."

The 1930 census recorded more than 54,000 New Rochelle residents, with 23 percent of the population as foreign-born white. That year, nearly 30 nationalities were represented in the city's 14 public schools. New Rochelle soon had the reputation of being the wealthiest city in New York State, per capita, and the third wealthiest in the country.

After many delays, refinancing, and restructuring, construction on the New York, Westchester, and Boston Railway began in 1909 and continued for nearly two decades. New Rochelle was one of the first communities to benefit from its service. On May 29, 1912, the first elegant railcar ran between East 180th Street and Morris Park Avenue to North Avenue in New Rochelle. "No expense was to be spared," Roger Arcara wrote in his book *The Forgotten Railroad*. "The railbed was cut, filled, leveled and graded for the smoothest of rides. The self-propelled coaches with powerful Motorola motors gave a fast and fluid, cleaner, quieter ride—at an astonishing speed of a mile a minute." In the photograph, a rail bed is being dug near Webster Avenue.

New York, Westchester, and Boston Railway engineers learned from the successes and failures of other rail lines. All aspects of this railroad were going to be the safest, sturdiest, and most maintenance free. The retaining walls and bridges of the railway were built to last for a long period of time. In this photograph, a work train is traveling across a temporary trestle with dirt that will be dumped along its sides to create a level track.

Tracks were extended to Larchmont by 1921. Four years later, Mamaroneck was linked. By 1929, passengers were boarding the two New York, Westchester, and Boston Railway lines in Westchester at stations in Harrison, Rye, and Port Chester and White Plains, Scarsdale, New Rochelle, Pelham, and Mount Vernon. Through cow fields, woods, and bogs, 30 miles of the New York, Westchester, and Boston Railway's electrified rail supplemented the New Haven Railroad and New York Central Railroad commuter train service.

113

The New York, Westchester, and Boston Railway stations were considered among the most well-designed depots in the country. Built in Renaissance, mission, or classic styles to harmonize with one another, they were intended to appeal to more sophisticated tastes, encouraging development of upper-end communities. The Wykagyl station on North Avenue (above) was responsible for the development of an entirely new residential and commercial area. The clay-roofed structure now has neighbors, but the building and stairs that led down to the tracks are still used. The Webster Avenue station (below) also still stands at the corner of French Ridge.

The Quaker Ridge station was actually a distance from its namesake. The station was off Stratton Road just below Weaver Street. The photograph below from a real estate promotion shows the station (center, left) and the deforested fields of former farmland prime for subdivision and new construction in New Rochelle's northeast corner near Scarsdale. However, the station ceased to be a selling point in the 1930s, as the line stopped functioning on January 1, 1938. Never reaching the heart of Manhattan or anywhere near Boston, the New York, Westchester, and Boston Railway went bankrupt.

The giant doors of the new high school swung open to accept the first students in September 1926. Designed in a style reminiscent of a chateau to reflect the community's founding by the French Huguenots, the building could accommodate all 9th- to 12th-grade students. The original high school building at 515 North Avenue became Albert Leonard Junior High School. Formerly one large lake used for the Mahlstedt family's ice-making business, twin lakes were created with a man-made causeway leading to the school, and the property fronting North Avenue formed Huguenot Park.

As part of the development of the former Mahlstedt property, its 1869 home, the "little brick house up in the woods," was transformed into the Huguenot branch of the New Rochelle Public Library. For seven decades, it was a charming midcity spot for readers and researchers of all ages. After closing due to financial constraints in 1992, a grassroots effort led by local residents lovingly restored the building to create the current Huguenot Children's Library.

When several new schools had to be built to educate the thousands of children whose families had recently settled in suburban New Rochelle, some of the best architectural firms were employed. The prestigious architectural firm of Starrett and VanVleck, which was responsible for considerable Manhattan structures such as department stores Lord and Taylor, Saks Fifth Avenue, and Bloomingdale's, were contracted to design Isaac E. Young Junior High School, Henry Barnard School, and Jefferson School. When Isaac E. Young Junior High School (above) was completed in 1929, the monumental collegiate Gothic building was called a "medieval castle of vast dimensions" by the local *Standard Star*. To complement its neighboring residences, Barnard School (below) was designed in an Elizabethan Revival style and completed in 1931.

Thomas Alva Edison (above) was on hand to turn the first spade of dirt for the construction of the Thomas Paine Memorial Library on Memorial Day in 1925. The famous inventor was a longtime member of the Thomas Paine Historical Association. The Colonial Revival building (below) was designed by architect Laurence Loeb. It is located on North Avenue just above the Thomas Paine Cottage.

The Girl Scout house was dedicated in April 1927. Sandwiched between the Thomas Paine Cottage and the Thomas Paine Memorial Library, the structure is located on North Avenue between Paine Avenue and Valley Road. The ceremonies were officiated by Mayor B. Benjamin Badeau, pictured here with girls. Local resident James West, the first executive director of the Boys Club of America, also attended the auspicious occasion.

Elizabeth E. Van Etten gathered together a group of 45 well-to-do women and formed the New Rochelle Women's Club in 1912, "to work for any and every sort of improvement in New Rochelle." In 1924, with membership nearing 600, the group built a large Tudor clubhouse on Lockwood Avenue. The Zion Baptist Church purchased the structure in 1965. The women's club continues its good deeds for the community.

When a 1923 fire destroyed the First Presbyterian Church at the west intersection of Huguenot and Main Streets, the firm of John Russell Pope, designer of the Thomas Jefferson Memorial, was hired for a new church at the top of Pintard Avenue. The congregation that grew from the early Huguenot French Church dedicated its new home in 1929. The building was listed on the National Register of Historic Places in 1976.

I. B. Cohen, Max Goldstein, Ben Seidenstein, Israel Streger, Joseph Silver, Max Kalmanson, Samuel Mishkind, Maxwell James, and others incorporated the Hebrew Institute in 1909. The group met in a series of temporary facilities, including the first YMHA, pictured here, which was built in 1916 on Lincoln Avenue. In 1927, 202 member families dedicated their new school-religious center at 31 Union Avenue. The institute's name was changed to Beth-El Synagogue in 1931.

An ice-cream soda and a bite to eat at the Boston Spa before a movie at Lowe's or RKO made for a great date. Next door, as shown in this late-1920s photograph, Leonard Talner has his jewelry shop with other stores in the Main Street and Centre Avenue building. Talner's Jewelers, one of longest-running businesses on Main Street, now occupies the entire first floor on its own.

As many as 2,500 theatergoers poured into Lowe's for a variety show, newsreel, and movie. They were seated by 25 to 30 ushers who were often dressed in costumes related to the movie's theme. Leading theater architect Herbert J. Krapp Jr. designed the Spanish Colonial Revival–style building, completed on Main Street in 1926, as well as the Proctor's Keith Albee's Theatre that opened on Main Street and Centre Avenue the next year.

Taking the gavel from Susan B. Anthony, Carrie Chapman Catt led the last and critical leg of the suffrage movement to the passage of the 19th Amendment, giving women the right to vote in 1920. Eight years later, Catt chose New Rochelle as her final home, purchasing a large gracious house on Paine Avenue. It could accommodate up to 200 for the teas she held for the League of Women Voters and Women for Peace and Disarmament. Catt was also active in the New Rochelle chapter of the Women's Christian Temperance Society and a supporter of her adopted community's history and public library.

On the site of the old Besly's Tavern, where meetings were held by the first Huguenot settlers and travelers along the old Boston Post Road found lodging for a night, New Rochelle's first skyscraper rose. Construction was begun on the Pershing Square site in 1929. Owners Herman Schiff and Sons spent $1 million to construct the 12-story building. Now referred to as the K or Kaufman building after a later owner, it was New Rochelle's tallest building throughout the 20th century.

Steering away from the typical black-and-white border signs of every other community, members of the New Rochelle Art Association took a novel approach to welcome people to their town. In 1923, 10 marvelous historically themed and unique signs, created by some of the country's best artists, were erected at key entries around town. Designed by metal artisan James Marsh, each had a decorative bracket holding a metal placard topped by a custom-cut crown illustrated by an artist. For a sign at Pelhamdale Avenue and Eastchester Road, Norman Rockwell chose to depict Revolutionary War soldiers. On Kings Highway, Clare Briggs employed a character from his nationally syndicated comic strip, letting all know that a "feller" could find a friend in New Rochelle.

BIBLIOGRAPHY

Arcara, Roger. *Westchester's Forgotten Railway, 1912–1937*. New York: Quadrant Press, 1972.
Bolton, Robert. *A Guide to New Rochelle and Its Vicinity*. New York: A. Hanford, 1842. Reprint, Weigold, Marilyn, ed. Harrison, NY: Harbor Hill Books, 1976.
Devane, Bro. Austin D. *History of the New Rochelle Public Schools*. Ph.D. diss., Columbia University, 1954.
Forbes, Jeanne A., ed. and trans. *Records of the Town of New Rochelle*. New Rochelle, NY: Paragraph Press, 1916.
Forbes, Robert Lucas, ed. *New Rochelle: Two Hundred and Fifty Years*. New Rochelle, NY: 1938.
Hadaway, William S., and Morgan H. Seacord. *Historical Landmarks of New Rochelle*. New Rochelle, NY: New Rochelle Trust Company, 1938.
Hoctor, Thomas A. *Red Shirt, Blue Shirt*. New Rochelle, NY: Centennial Committee, New Rochelle Fire Department, 1961.
Hufeland, Otto. *A Good Humored Traveler in New Rochelle One Hundred Years Ago*. New Rochelle, NY: Huguenot and Historical Association of New Rochelle, 1929.
New Rochelle Chamber of Commerce. *New Rochelle, the City of the Huguenots*. New Rochelle, NY: Knickerbocker Press, 1926.
Nichols, Herbert B. *Historic New Rochelle*. New Rochelle, NY: New Rochelle Board of Education, 1938.
Pallen, Condé B., ed. *New Rochelle: Her Part in the Great War*. New York: Walter Castell Tindall, 1920.
Rosch, John. *New Rochelle on the Sound*. New Rochelle, NY: 1903.
Rockwell, Norman. *My Adventures as an Illustrator*. Garden City, NY: Doubleday, 1960.
Schetterer, June. *A Celebration of Women in New Rochelle History*. New Rochelle, NY: New Rochelle Council on the Arts and New Rochelle Public Library, 1986.
Standard Star. *New Rochelle in Pictures*. New Rochelle, NY: Standard Star, 1931.

About the New Rochelle Public Library

The New Rochelle Public Library serves the 72,000 residents of New Rochelle from its main building in the downtown business district and the Huguenot Children's Library, located in Huguenot Park. As a community resource, the library seeks to improve the life of every citizen in the city. It is dedicated to encouraging learning at all stages of life, to protecting intellectual freedom, and to providing fair and equal access to information. The library offers a comprehensive collection that includes retrospective and current materials, up-to-date technology by which information can be accessed, and a wide range of services and programs tailored to a diverse audience.

The local history collection of the New Rochelle Public Library is the largest repository of historical records pertaining to the city's long and illustrious history and includes photographs, postcards, maps, books, manuscripts, and ephemera. The library's E. L. Doctorow Local History Room, which was named for the former resident and author who researched *Ragtime* and other novels using the material, houses most of the collection. The room is open to researchers, scholars, and the general public during regular library hours. Archived items are available for use by appointment. An index and finding aids to the entire collection are available on the library's Web site, www.nrpl.org. Information on ordering copies of images can also be found on the Web site or by mailing an inquiry to Local History, New Rochelle Public Library, 1 Library Plaza, New Rochelle, New York, 10801.

Discover Thousands of Local History Books
Featuring Millions of Vintage Images

Arcadia Publishing, the leading local history publisher in the United States, is committed to making history accessible and meaningful through publishing books that celebrate and preserve the heritage of America's people and places.

Find more books like this at
www.arcadiapublishing.com

Search for your hometown history, your old stomping grounds, and even your favorite sports team.

Consistent with our mission to preserve history on a local level, this book was printed in South Carolina on American-made paper and manufactured entirely in the United States. Products carrying the accredited Forest Stewardship Council (FSC) label are printed on 100 percent FSC-certified paper.

MADE IN THE USA